George DeWolfe's Digital Photography Fine Print Workshop

George DeWolfe

McGraw-Hill

New York Chicago San Francisco
Lisbon London Madrid Mexico City
Milan New Delhi San Juan
Seoul Singapore Sydney Toronto

The McGraw-Hill Companies

The McGraw-Hill Companies
160 Spear Street, Suite 700
San Francisco, California 94105
U.S.A.

To arrange bulk purchase discounts for sales promotions, premiums, or fund-raisers, please contact McGraw-Hill at the above address.

George DeWolfe's Digital Photography Fine Print Workshop

1234567890 WCK WCK 019876

ISBN 0-07-226087-4

Acquisitions Editor	Roger Stewart
Project Editor	Janet Walden
Acquisitions Coordinator	Agatha Kim
Technical Editor	Kathy Eyster
Copy Editor	Lisa Theobald
Proofreader	Paul Tyler
Indexer	Valerie Robbins
Composition	Jimmie Young / Tolman Creek Design
Cover Design	Jeff Weeks

This book was composed with Adobe® InDesign®.

About the Author

George DeWolfe has been a photographer since 1964. He studied with Ansel Adams and extensively with Minor White in the 1970's, and studied Perception with Dr. Richard Zakia.

He taught Zone System and Perception at The New England School of Photography, The University of Idaho, and Colorado Mountain College. He initiated the Appalachian Mountain Club Photography Workshop and teaches numerous workshops and seminars throughout the country, including Large Format, Quadtone and Digital Fine Printing, The Master Print, Advanced Photoshop, Contemplative Photography, and The Contemplative Landscape. For many years a contract photographer, his clients included APC, Eastman Kodak, Hewlett-Packard, Teledyne Water-Pik, United Bank, Yamaha, J.C. Penny, and Sears.

George has published three books, most notably, *At Home in the Wild*, edited by David R. Brower, and has contributed to dozens of others including *The New Zone System Manual, Zone Systemizer, Perception and Photography, Visual Concepts for Photographers, The Dictionary of Photography,* and *Creative Digital Printmaking*. He is in the process of writing *Contemplative Photography* and has published an Adobe Photoshop plug-in, Optipix.

He has shown forty one-man and numerous group exhibitions and is in several permanent collections. He is currently a senior editor for *CameraArts*, and an advisor to Epson America, Adobe, Hahnemühle, and Polaroid. Awards include *Award for Artistic Excellence* from The National Park Service. He holds an MFA in Photography and Graphic Art from The Rochester Institute of Technology.

George's passions are teaching visual and digital photography skills and photographing the mysteries of the world. He combines the structure of ancient Chinese landscape painting with the structure of Western landscape genres to achieve his mysterious style. And when he has the time, he plays the bluegrass 5-string banjo.

Contents

Part II | The Workshop

Foreword

Art, photography, and the decisions that unify the two are the pivotal elements to make photographs with, dare I say it, soul and meaning. You purchase the cameras, lenses, computers, and printers, and then you strive to make a print that reflects something you *felt* at the time of exposure. This is another of life's curve balls—you have a process that sounds so simple yet is amazingly challenging to execute. Many photographers find this difficult because, easy as it appears, it's quite a journey to take a *feeling* and make it into something you can put in a picture frame. You struggle to translate the reason-for-shooting into an image that has meaning to others (and maybe they'll even purchase it). There's that fundamental breakdown between understanding the original inspiration (why you clicked the shutter) and how to take those raw materials and transform them into a moving, inspiring photographic print.

It's not easy. If it were, we'd all be making a living as artists. Yes, you can read all the technical books to learn about exposure, contrast, and color, but without a foundation of critical expressive thinking, you're on your way to making clichés at best and mediocrity at worst.

So how can you best approach this combined goal of mastering both aesthetics and technique? And how do you go about designing your personal workflow so you spend more time with the creative and fun parts of photography and less time shaking your head at prints that look nothing like what you envisioned?

Reading this book, you will discover an author who makes the intelligent and much appreciated effort to define the "whys" of photography in addition to the much easier "hows." Indeed, you know you're dealing with a photographic artist when he takes the time to explain the difference between *ambient* and *reflected* light. Heck, how many digital imaging authors even take the time to talk about *light* in general terms? In a typical Photoshop book, you're more apt to encounter a longer exploration of the Eyedropper tool than you are to glean any appreciation for the qualities of light that make an image a winner or a sleeper. Bottom line: most of us need as much help with the decisions of aesthetics as we do with the mechanics of photography. Score another point for George Dewolfe's approach.

As something of a digital pioneer myself (the first edition of my *Making Digital Negatives for Contact Printing* was published in 1995, during the Paleolithic period of digital imaging), I've witnessed the right way and the wrong way to navigate the

amazing metamorphosis of photography as it changes from a chemo-mechanical realm into a digital-ink discipline. Anyone who reads books to learn has encountered authors who know how to do things themselves, and in contrast, authors who know how to teach others to do those same things. Happily George DeWolfe falls into the second camp. His style is authoritative but never condescending. He's scientific when needed but never technical for technical's sake. In other words, he takes pains so you don't feel overwhelmed or misled. And, I must add, he is not a computer nerd. His explanations are spot-on, simple, and concise. What more could you want?

You have to decide where your interests in art and technique intersect. George feels strongly that the craft and art of photography are intimately connected. His joined-at-the-hip approach will leave artists with jaws dropped. George certainly explains *how* to achieve prints with glowing highlights, seductive midtones, and deeply lush shadows. But more important, he shows you how to think like an artist, making decisions about color, tonality, sharpness, and all the rest from years of experience. Yes, this is the stuff that separates the technicians from the artisans and George is a master. On the other hand, if your idea of digital excellence is using as many of Photoshop's blending modes as possible in each and every image, you might want to look elsewhere. Believe me, if flexing technical muscles is your primary passion, George won't be disappointed at losing you as a reader. For the rest of us, we leave his last pages as better artists and better digital printers.

So do you really need yet another "Photoshop book" cluttering your desk or bookcase? The short answer is "Yes," as long as the author has conveyed his passion for photography and has written in understandable language. And guess who has done just that? Yep, George DeWolfe. With his help, you'll be putting more of your own feelings into those picture frames.

Dan Burkholder
www.danburkholder.com

To the memory of Richard G. Smith, mentor and friend, who got me into photography, and Richard D. Zakia, mentor and friend, who taught me how to see.

Acknowledgments

Ten years ago, few people knew how to print excellent digital photographs. Graham Nash and Jon Cone, of Nash Editions and Cone Editions Press, respectively, were among the few. They were pioneers. Jon first opened my eyes to the *possibility* that such a feat could be accomplished. When I first saw his digital platinum prints from an Iris printer, my reaction was, "Do you take MasterCard and Visa?" That was 10 years ago. Today, I cannot imagine a world without digital fine printing.

A then fledgling magazine, *CameraArts*, where I am now senior editor, asked me to take over the duties of exploring and writing about this technology, largely because I had been using Photoshop since version 1.5 and had much familiarity with digital studio photography. I formed a loose group of people I called the CameraArts Research Group. It consisted of Huntington Witherill, an exceptional fine art photographer in Carmel, California (who was exploring digital printing); Kevin Anderson, a outstanding commercial digital photographer in Chicago (now of Tuscon); David Applegate, senior photographer at the National Gallery in Washington (where much original digital experimentation was occurring); Dan Culbertson, a NASA rocket scientist (I always joked that we had a rocket scientist on our team), who dealt with complicated workflow ideas; and John Paul Caponigro, master of the digital image and one of the early proponents and teachers of this technology. Together, we were a considerable force. We verified one another's work and laid the groundwork for many of the principles found in this book. The workflow is as much a tribute to their contributions as my own.

Manufacturers also contributed equipment, software, media, and supplies to this new workflow concept. These were Epson, Apple, Adobe, Ilford, Hewlett-Packard, Polaroid, Legion Paper, Hahnemühle, GretagMacbeth, Cone Editions Press, Monaco/ X-Rite, Lyson, MIS Associates, Lumijet, GTI Lite, ColorVision, Wacom, PictoColor, nik Multimedia, Reindeer Graphics, Nikon, Canon, Olympus, Iomega, LaserSoft, Crane, Lexar, SanDisk, Microtek, and Calumet. A multitude of people within these companies also helped me.

Many people have been my informal advisors and have all added something, however large or small, to the workflow effort: Julieanne Kost, Mac Holberg, Henry Wilhelm, John Nack, Richard Newman, Larry Danke, Bill Bergh, John Panazzo, Mark Rodagna, Stephen Johnson, Theresa Airey, and Joe Meehan. I would like to highlight,

especially, my cohort Chris Russ of Reindeer Graphics, who engineered the code for Optipix software that is featured in this book.

Without the cooperation of the many workshop venues in this country—Santa Fe Workshops, Rocky Mountain School of Photography, Palm Beach Photographic Center, Cone Editions, the Charleston Center for Photography, The Arts Center of St. Petersburg, the University of Hawaii, and others—the Digital Fine Print Workshop would not be a reality. I am thankful to Reid Callanan, Jerry Corvousier, Fatima NeJame, Jean and Neil Chaput Saintoge, Jon Cone, Tim Cooper, Beth Reynolds, Dave Russin, and Jack Alterman for making these workshops possible and successful.

I cannot say enough about my students over the years who took the Digital Fine Print Workshop all over the country and put it and me to the ultimate test. Thanks to them and their many suggestions, the workflow is a success.

The editorial staff at McGraw-Hill made significant contributions to the layout and editing of this difficult subject. Roger Stewart, my editor, frequently kept me from straying off the path; Agatha Kim kept production moving smoothly; Kathy Eyster expertly edited all my technical mistakes; and Janet Walden, Lisa Theobald, and Jimmie Young achieved my highest marks for the real job of editing and layout of this book better than I ever dreamed.

Lastly, I'd like to thank my son, Luc, for helping me scrutinize inkjet prints for many years, even when he had better things to do, and my partner and companion, Lydia Goetze, who is the only person I allow to edit my printed voice as well as my flow of ideas and technical clarity. This book could not have been written without her constant and loving care.

To everyone who contributed to this book, many thanks.

Introduction

When I was 11 years old, in 1956, my father bought me a printing press. I'd been using a funky, inexpensive hobby press that had individual pieces of rubber type I assembled on a drum and then printed on a piece of paper. When Dad saw that I had an interest in printing, we decided to buy a "real" printing press, a letterpress from the Kelsey Company in Meriden, Connecticut. It had a 5-by-8–inch platen, which meant that the largest size I could print was 5-by-8 inches. Large type cases were full of what was then known as "hot type," because it was made from a tin, antimony, and lead metal alloy and cast in individual characters that I had to hand set individually into the 5-by-8 *chase* and secure with *quoins*, a kind of squeeze clamp that helped keep everything tight for printing. Ink went on a large, round ink table. I pressed a large lever, and the monstrous, cast iron behemoth printed stationery, business cards, and even books. A year into the project, a friend and I decided to print a newspaper we called *The West Side News*. We canvassed the neighborhood, collected subscriptions, and printed a weekly gossip rag. We made money and knew we were destined for publishing fame.

Three blocks from our house was a print shop run by two guys named Henry and Jack. I spent hours there watching how they worked, and occasionally Henry would give me a couple of small jobs that he didn't want to be bothered with. The shop even had a Merganthaler Linotype machine that fascinated me. It would cast lines of type through a complicated system of heated lead, dies, and conveyers. It was much quicker than setting type by hand, and I frequently had Henry set large jobs for me with the Linotype. Once, he let me try it out, and I knew from that point on that I was a printer.

From this early experience, I learned the importance of craft. Half a century later, sitting at my computer and my inkjet printer making photographs, I am consummate craftsman. Every aspect of my photography and printing is done with the utmost care, skill, knowledge, and thoughtfulness. I have learned the craft, art, and skills of photography and printing from the best, and I hold experience that historically takes me back almost to the beginning of Gutenberg's introduction of movable metal type in 1550.

This book is about *craft*. It's not about tips or techniques or even Photoshop, really, although these important factors form much of our discussion, and they have their place. Craft is about attitude—the way you approach the subject. It is about excellence and consistency and practice. Craft synthesizes art and technology and makes them

work together seamlessly. We not only have to know how the machines work, but we also know and apply the making and design of photographs, and the printing of ink on paper. We must constantly synthesize the technology with the art in a rapidly changing, complex, and often frustrating digital age.

What you'll learn from this book is how to practice craft. The practice of the craft of digital fine printing (or any other craft for that matter) involves four things:

- **Excellence** Without excellence as a standard, we have no craft. The quality of our work will not be pleasurable to produce, the work will look half-finished, and no one will buy it. Excellence is also an attitude as well as a result in the print. The continuous striving for excellence produces the few masterpieces that any artist makes in a lifetime.

 An apprentice traditionally learns excellence by working with a master of the craft. It takes many years of practice to achieve the standards set by the master, and nothing, absolutely nothing, takes the place of this long internship, love, and dedication to the task. We learn excellence from a master's standard and the hard work that attends it.

- **Consistency** Repeatability is one of the hallmarks of any artist and always of a craftsman. Consistency allows us to know and intuitively measure that we have achieved a certain level of proficiency in the long road of mastery. And it allows others to recognize our stamp of authenticity.

- **Workflow** *Workflow* is a modern word that means a way of working that produces excellent prints on a consistent basis. It is the sequence of ideas, steps, and techniques patterned together that creates the dependable final result.

- **Evaluation** Evaluation—self-evaluation, really—allows us to refine our skills continually to make excellent prints better and occasionally create a masterpiece. It's not the kind of criticism we find in academic circles, where few masters exist, who neither have the right nor the experience to judge adequately; instead, evaluation is self-criticism based on the works of real masters, who do, indeed, set the standards.

The basis of all this is the workflow—The Digital Fine Print Workshop, in our case. The workflow in this book is not a gospel (although it may be good news to many) but a model. It is an aid to the achievement of excellence and consistency. Try it and learn it, use it to its fullest, give it a chance, and if it doesn't produce what you want, modify it and make it your own. Make photographs and make prints—lots of them.

One caveat that I adhere to is called the *Closed Loop*. The Closed Loop means that you do everything in the workflow yourself—and I mean *everything*. The Closed Loop is at the heart of every recommendation I make about equipment and workflow needs. The late President John Kennedy once said that it is morally wrong to abandon your own judgment. In the Closed Loop, this means that there is no sending negatives out to be drum-scanned, no outsider printing your pictures, nobody telling you what you

should do to your prints. The Closed Loop concept is not radical; it comes from the history of photography.

More than 30 years ago, I made a decision that has affected my whole life as a photographer. When I was a photography and printing graduate student at The Rochester Institute of Technology, I spent one afternoon a week going through the archives at the George Eastman House. The important lesson I learned was that all the great prints in the history of photography were made by the photographers themselves, not by an assistant or some other professional functionary. Of course, I'm not talking here about great photographs, just the great prints by photographers who also happened to be great. I made a decision then never to let anyone else print my photographs, and it became the basis of the Closed Loop in digital photography and printing. Only the photographer who took the picture can print an honest and authentic artistic statement about the image. I would like to repeat that: *Only the photographer who took the picture can print an honest and authentic artistic statement about the image.* This is an overt challenge to photographers who hold different opinions, and it is based entirely upon looking at the great prints in the history of photography and 50 years of experience.

The first part of this book—Chapters 1 to 3—introduces you to the qualities of the digital fine print and their evaluation. For those of you who don't realize the need for this preliminary discussion and want to proceed right into the workshop, you can go to the second part—the workflow itself, in Chapters 4 to 11—and get to work. I'd recommend doing this, however, only if you're already fairly well along in digital printing. For those of you who need to buy equipment and set up a studio or workstation, my personal recommendations are listed in Appendix A. How to set up the Photoshop CS2 workspace and a *small* discussion of color management are discussed in Appendixes B and C, respectively. Perhaps everyone should read Appendixes B and C first, on second thought. Even though they are at the back of the book, they may be the first things you need to consider before continuing, to keep the workflow smooth.

As a teacher, it is my earnest desire that you be the best printers you can be. This book was written for all who want to see and print great photographs, and who in seeing and printing, wonder and wish to understand.

George DeWolfe
Southwest Harbor, Maine
March 2006

PART I
DIGITAL FINE PRINTING:
AN OVERVIEW

What Is a Digital Fine Print?

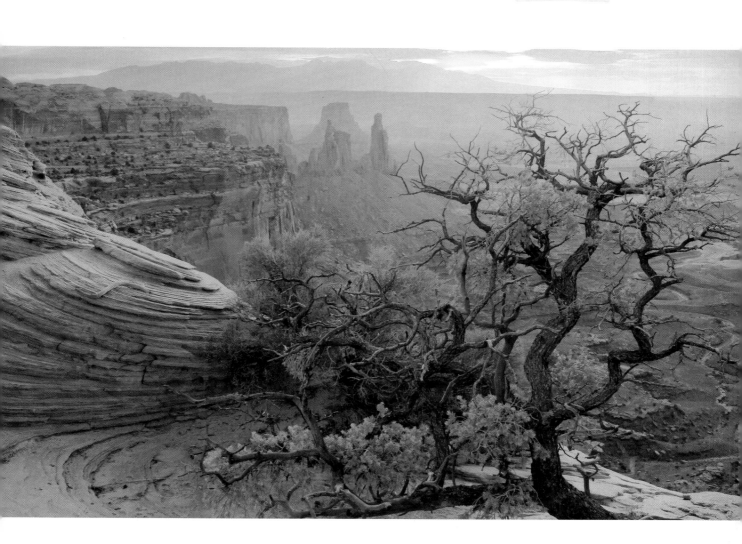

A digital fine print comprises aesthetic (artistic) qualities that can be controlled by technical means. Printing is not just a technical exercise or an aesthetic one; it is a combination ruled by both in harmony. We control six major aesthetic qualities when we produce a digital print: cropping, contrast, brightness, color, defects, and sharpness (see Figure 1-1). We must learn to control each of these expertly to produce a consistent workflow for making excellent prints.

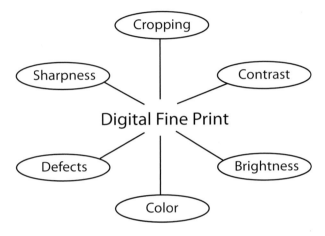

Figure 1-1: Six aesthetic qualities of a digital fine print

Qualities of a Digital Fine Print: The Essence of Craft

The essence of the craft of digital fine printmaking involves time and persistence aimed directly at the intuitive integration of both aesthetic and technical qualities. Most, if not all, technical problems can be discovered, diagnosed, and corrected. However, even aesthetic concerns are linked to technical ones, although aesthetics are often elusive and personal.

A fine art photograph proceeds from an aesthetic stance and develops according to the photographer's technical ability to achieve the desired aesthetic result. So, in a very real way, all decisions involved in making digital fine prints begin as aesthetic ideas and end with technical solutions. It is in this particular respect that the Digital Fine Print Workshop— a

workflow input to print—exists. If we look at digital fine printing as a mix of aesthetics and technology, we not only put ourselves in the correct artistic flow of things, but we begin to perceive technical concerns as aesthetic ones instead.

This attitude is important. By thinking of digital fine print problems as aesthetic concerns, diagnosis and solutions of the problems become easier. My observations during decades of teaching and photography show that many photographers tend to make technical corrections before fully diagnosing the problem. We tend to see the problem first as technical, such as a contrast problem that can be fixed in Photoshop using Curves. If we think in terms of aesthetic properties, however, we can see, describe, and diagnose before any technical solution is applied to the work. Instead of deciding that contrast can be fixed by a tool, we can see it as a change in gradation from shadows to highlights and determine how we want those gradations to be adjusted. This is the way artists think when they are creating: aesthetic intent, technical solution. They make the technical tools serve their aesthetic needs, not the other way around.

In a digital fine print, as in an orchestra performing a score, the whole is greater than the sum of the parts. All the instruments must be tuned properly and the conductor must struggle to keep the harmony of the whole over the sound of the individual instruments. When one instrument is out of tune or too loud or soft, the whole suffers. For a photographer making a digital fine print, the parts must be harmonious to bring out the whole, and as with the orchestra, the work continues until the piece is finished.

Understanding and practice in using the instruments of the workflow will allow you to master this new photographic craft. The art of mastering any craft takes time and patience. Digital fine printing is a "global skill," similar to playing the piano (or any instrument, really). It can be challenging to play smoothly as you translate musical notation for both the left and right hands and use both hands on the keyboard to play a complex piece, while using the foot pedals at the same time to achieve tone and volume. As with digital fine printing, to get comfortable with it, you have to practice, practice, practice.

When we first look at a digitally printed image, our initial impression is the most important one, because we see the whole first, and in general

sense whether the shot works or doesn't work. The parts of the photograph must work in harmony with the whole, and as the conductor, the photographer must be familiar with the instruments playing the parts that make up the whole. Let's take a brief look at these instruments that, harmoniously or not, make up the entirety of a digital fine print. These instruments will continue to be major players throughout this book.

Cropping

Deciding where to crop is truly an aesthetic challenge. Often treated mechanically, cropping is an important aesthetic decision because it frames the composition the way the photographer saw the image *precisely*. Making cropping judgments is one of the most important and difficult procedures a photographer can perform. Cropping unifies an image as a whole, and this unification is frequently the reason for employing cropping as an aesthetic tool rather than a technical one (see Figures 1-2 and 1-3).

Figure 1-2: Distracting dark patches appear in the lower left and right corners of the photograph.

Figure 1-3: Cropping the photograph unifies the finished image.

Contrast

Contrast is a visual measure of the number of gray values that appear between the highlights and shadows of the image. Contrast can act in an overall sense, making the picture appear not to have enough grays (*contrasty*) or to have too many grays (*flat*) between highlights and shadows, or it can act in local areas of the image, making them appear flat or contrasty, but not necessarily affecting the overall contrast. Contrast and

brightness settings are often confusing to beginning photographers because they are sometimes difficult to tell from one another. Correct contrast usually shows well-separated *midtone* values and textured highlights and shadows.

Figures 1-4 through 1-7 demonstrate how contrast affects the appearance of an image.

Figure 1-4: With too much contrast, the highlights are all pure white and the shadows are all black; here, the midtone contrast is set too high.

Figure 1-5: With correct contrast settings, the highlights and the shadows are full of detail and substance and the midtones are well separated.

Figure 1-6: This flat image was shot in direct sunlight with only midtone values present and virtually no highlights and shadows.

Figure 1-7: This corrected image with contrast added separates the midtones and creates textured highlights and shadows.

Brightness

Brightness is the overall lightness or darkness of the image. The key for correct brightness is the sense of the light in the midtones, highlights, and shadows. Brightness is a rational, visual, and intuitive exercise. Only the photographer who took the picture can judge whether a print of it is correct in brightness. Brightness can affect the overall sense of light in the image or the light in any specific local area.

Figures 1-8 through 1-10 demonstrate how brightness affects the appearance of an image.

Figure 1-8: This photograph is too dark overall; brightness has not been adjusted, and the detail in the shadows is gone.

Figure 1-9: This photograph uses the correct brightness settings.

Figure 1-10: This image is obviously too bright because the textured highlights are blown out.

Color

Managing and calibrating *color* for digital printing involves important steps at the very beginning of the workflow: calibrating the computer monitor, choosing correct color settings in Photoshop, making a proper proof setup, and using accurate printer profiles for the final output of the digital print. These actions help the photographer achieve the image originally visualized. Only with proper color management can the aesthetic problems of color in an image be addressed. The subtle aesthetic judgment of detecting off-color in the image and the method used to correct it can then be handled safely.

Figures 1-11 and 1-12 show how color affects the appearance of an image. In Figure 1-11, the glass was photographed with outdoor white balance under tungsten light in a restaurant. (The photographer was probably under the influence of two or more of the pictured liquid refreshment and unwittingly made a bad digital decision.) In Figure 1-12, the color was adjusted to more realistic values.

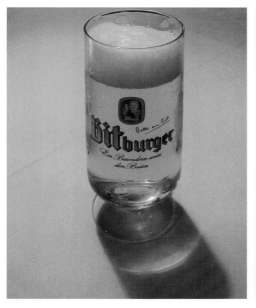

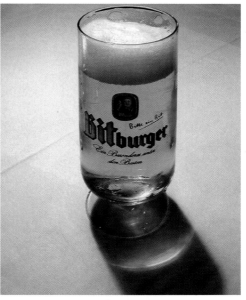

Figure 1-11: This image shows an extreme example of an off-color photograph.

Figure 1-12: The color was adjusted in this version.

Defects

When you view an image carefully, you'll notice whether *defects* are present, such as dust, scratches, water marks, and other *mechanical* problems. One major defect that often appears in digital images is the notorious problem of image *noise*. Noise is a special defect that comes with underexposure, long time exposures, and high ISO. Noise can easily be seen in even-toned areas like the sky, but it is especially noticeable in the shadows. Noise reduction is always a limiting procedure, because the more you get rid of the noise in a photograph, the more blurred the image becomes. The surest prevention for high image noise is to shoot at the lowest possible ISO setting in your digital camera. Even though noise is a defect, it is usually handled along with sharpening because the two are the opposites of each other.

All noise defects can destroy the aesthetic integrity of any fine print. Luckily, defects are not part of the content of the image and can be removed without aesthetic remorse, as demonstrated in Figures 1-13 and 1-14.

Figure 1-13: Image noise is uncorrected in this image, viewed at 100 percent.

Figure 1-14: The noise was reduced—blurred—in this picture (the effect has been exaggerated).

Sharpness

The aesthetic idea of *sharpness* has evolved from our desire for optical focus and clarity of detail. The objects in a photograph are either in focus or out of focus; they are resoundingly clear in detail or they aren't. It is important to be able to decide what in the picture needs to be sharp and what doesn't. As with many image qualities, sharpness can be an issue of personal aesthetics, or it can define a photograph in an obvious way by making something important clear to the viewer.

Sharpness (or blurring, if that's what you're after) is a result of many factors. Following are the main protagonists:

- **Camera lens focus** Was the image sharp to begin with?
- **Resolution** Did you photograph at a high enough file size?
- **Edge and detail clarity** How much Unsharp Mask is necessary?

Figures 1-15 and 1-16 show the same image before and after sharpening, respectively.

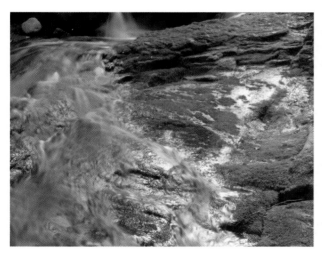

Figure 1-15: The original Adobe Camera Raw image unmodified

Figure 1-16: The image after detail enhancement and sharpening—quite a difference

Introduction to the Digital Fine Print Workshop

The order in which the six aesthetic properties of cropping, contrast, brightness, color, defects, and sharpness are handled when diagnosing and printing is important. Usually, the worst offender is often recognized first, as it tends to be the most glaring of the group and demands your immediate attention before you can correct other issues. In a normal photograph, however—one in which all the properties are relatively equal—you can deal with these issues in a consistent way: it's called a *workflow,* and it is the basis of the Digital Fine Print Workshop.

A workflow allows you to accomplish all the steps necessary to make a digital fine print in a consistent, simple, and efficient manner. If you follow a workflow, no important step, process, or technique will be left out, and you can be assured of consistent and high quality prints. The following discussion is intended as an excellent and complete guide for accomplishing high quality and consistency, but you may find it necessary to modify the process for your own purposes. You can gauge necessary changes only by practice and experience in making prints.

The workflow takes into account all of the "instruments in the orchestra" and places them in a smooth-flowing composition that allows the optimization of each without unnecessary corruption of the image from any of them.

Let's take a brief look at the workflow (Figure 1-17) and see what each step accomplishes.

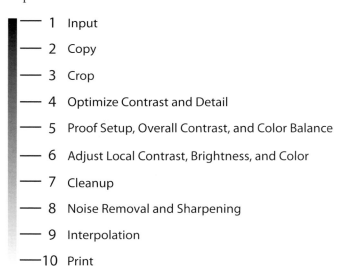

1 Input
2 Copy
3 Crop
4 Optimize Contrast and Detail
5 Proof Setup, Overall Contrast, and Color Balance
6 Adjust Local Contrast, Brightness, and Color
7 Cleanup
8 Noise Removal and Sharpening
9 Interpolation
10 Print

Figure 1-17: The workflow of the Digital Fine Print Workshop

Step 1: Input

Input involves transferring your image from a digital camera into Photoshop on your computer. The image should be of the highest possible quality in sharpness, contrast, and color, and as free of defects as possible. Photographers who want the highest possible quality will want to input *16-bit images* from a digital camera (often called RAW files because they have not been altered in any way).

Note

The Digital Fine Print Workshop is a 16-bit workflow from input to print. But for those of you who use cameras that make only JPEG files, the process will work for you as well.

Step 2: Copy

When you first open an image in Photoshop, you need to make a copy of it and save it in a folder made especially for that image. This allows you to save the image in many different forms and at various stages in the workflow. Many photographers prefer to use PSD (Photoshop format) or the TIFF format.

Tip

JPEG photographers should save a JPEG file to a TIFF *immediately*. If you keep saving a JPEG file to JPEG format, the image is repeatedly *compressed* so that successive files become more and more corrupted until the image is no good for any purpose.

Step 3: Crop

Many photographers never crop and make it a point never to adjust the original camera image at all for aesthetic reasons. These photographers can eliminate this part of the workflow. However, for those of us who do crop our photographs, this is probably the best time to do it. Others may want to crop at the end of the workflow just before printing, but you can determine this only with practice and experience. Always remember that aesthetic judgment precedes use of the Crop tool.

Step 4: Optimize Contrast and Detail

Contrast is the supreme technical problem of photography. Nothing is so aggravating as trying to control the contrast of light from highlights to shadows in a scene. In traditional print photography, the photographer's major hurdle has always been the range of the paper—1:50 at best, but it's usually 1:32, which means five stops of detail from highlights to shadows. Because of this need to control contrast, the Zone System was invented to manipulate the exposure and development of the negative to fit the scene to the final silver print. In the darkroom, different contrast grades of paper or different variable contrast filters were used. A multitude of chemical techniques and developers were used to correct every contrast problem from extreme underexposure to extreme overdevelopment.

In the Photoshop *lightroom*, similar contrast controls are used, but they have different names. Optimum contrast—the well-separated tonal range from highlight to shadow in the photograph—is controlled with several techniques depending on the severity of the contrast problem. Because contrast is such an obvious issue visually, it is the first step you consider as a real Photoshop adjustment. If contrast is not addressed at this point in the workflow, everything else will suffer both aesthetically and technically.

Along with contrast, detail optimizing is critical. During RAW interpolation and JPEG compression, the image suffers a number of qualitative problems, most noticeably resolution softness. It is important to restore the original resolution captured by the camera sensor. The Refocus and Detail Sharpener plug-ins from Optipix can be used to solve this problem quickly.

> **Note**
>
> Appendix A includes a table with web addresses for the various companies and manufacturers mentioned in the book.

Step 5: Proof Setup, Overall Contrast, and Color Balance

If your image is in color, you need to set the correct Proof Setup profile in Photoshop to see how the final print is going to look on the monitor. After Proof Setup, you need to adjust contrast and brightness and balance the overall color of the image to account for the change that Proof Setup provides.

Much confusion and bewilderment can exist at this stage of the workflow and misjudgments here affect the color of the final print. A number of color balancing techniques are available in Photoshop, and some third-party color balancing software is also available. Black-and-white proof setup is not necessary for printing through the Colorbyte ImagePrint RIP driver.

Step 6: Adjust Local Contrast, Brightness, and Color

For many photographers, adjusting local contrast and brightness is another difficult part of the workflow. The problem comes not in any real technical sense but in judging which areas in the image need to be locally adjusted. This takes practice and patience. The more you adjust local contrast and brightness in photographs, the better you get at it. Here is where diagnosis of what is wrong with the picture in ever-increasing minute levels can improve the print.

As with local contrast, you may find that you need to make local changes in color. For example, a field of yellow flowers may not be yellow enough to you, so you'll need to increase the color *saturation* (the intensity of the color).

Local contrast and color adjustments don't involve just pushing buttons in Photoshop. You must learn to diagnose what needs to be changed and then decide which tool to use to change it—diagnosis first, repair second. Figures 1-18 and 1-19 show an image before and after adjustments.

Figure 1-18: RAW image before any adjustment

Figure 1-19: Image after a slight change in contrast with Levels, with a lot of local contrast and color enhancement

Step 7: Cleanup

At this step, you get rid of defects, spots, scratches, and other artifacts not considered part of the content of the original image. If you clean up at the beginning of the workflow, overall contrast and color balance might affect and enhance some corrected defects; if you wait until the end of the workflow, the marks made by the soft brush used for cleanup won't show after sharpening.

Step 8: Noise Removal and Sharpening

Any adjustment in Photoshop causes image degradation in some way. Sharpening restores the image to its original (or better) sharp condition after being corrupted by operations in Photoshop. Many types of sharpening routines can be used—some concentrate on fine detail, others on edges, and others offer a combination of sharpness and blur to counteract noise. Noise, although considered a defect, is the exact opposite of sharpening. It is addressed now, rather than in the previous step, because noise removal and sharpening have to be adjusted together to achieve a balance between them.

Step 9: Interpolation

Interpolation allows you to enlarge an image past its optimum resolution or size. This is the very last adjustment you should apply to an image before printing, because the large file size that goes with interpolation is often unmanageable in any workflow using Photoshop. Edge sharpness is frequently a problem when interpolation changes the image, and many photographers add a little sharpening tweak at this point to offset this problem.

Step 10: Print

As of this writing, in my opinion, only a few inkjet printers are worth buying for high quality archival output: the Epson Stylus Photo R2400, and the Epson Stylus Pro 4800, 7800, and 9800. These all print color extremely well and can be used with custom profiles (recommended) from sources such as www.inkjetmall.com and various paper manufacturers' websites.

> **Note**
>
> Those who want to print in black and white and use papers other than Epson should purchase the ColorByte ImagePrint RIP or the QuadTone RIP software (see Appendix A).

Evaluating the Qualities of a Digital Fine Print

During a digital fine print workshop I was teaching, my students asked me if I would evaluate two black-and-white photography exhibits hanging in the workshop gallery. Both sets of prints were of similar content—landscapes of Florida's Everglades—but differed vastly in quality. I asked the students to choose which exhibit they liked the best, and they all chose the one with superior quality. When I asked them to tell me why they chose one over the other, however, no one could come up with a decent evaluation. When I pointed out to them that the gray values in the inferior exhibit were not well separated and that the well-printed exhibit had well-separated grays, they immediately saw and understood the difference.

Evaluating the six qualities of a digital fine print is the most important skill a photographer can learn in printing photographs. Everything we do technically in Photoshop *relies* on our ability to discriminate between and among all six qualities, sometimes in minute degrees of barely recognizable difference. Evaluation is key.

To keep with our analogy of the orchestra, the conductor always looks for and continues to strive for wholeness in the presentation. *He evaluates the instruments continually.* If some instrument is out of tune or playing the wrong notes, the conductor notices this and brings the contending clamor back to unity. He knows the abilities and shortcomings of each instrument and strives to blend each seamlessly into the whole and unified presence of the performance. This is precisely the goal of a photographer seeking to make high quality digital fine prints: W*e seek a unified presence, we know the instruments, and we evaluate continuously.* We are the conductors of the print.

Seek a Unified Presence

Almost every digital file has something wrong with it. Your job as digital fine printer is to recognize what's wrong and fix it so that the image has unified presence, wholeness, and harmony. Your first look at the original RAW or JPEG file should tell you visually which one of the six qualities is the most glaringly wrong—the one that stands out as most needing to be corrected. The process of visually isolating each of these qualities is called *thin-slicing*, a term coined by Malcolm Gladwell in his book *Blink: The Power of Thinking Without Thinking* (Little, Brown; January 2005). Gladwell writes, "Thin-slicing refers to the ability of our unconscious to find patterns in situations and behavior based on very narrow slices of experience." It allows us, he says, to make "very quick judgments based on very little information." This is how the conductor can make quick

evaluations of the instruments in the orchestra and bring them back into harmony. All experts at digital fine printing thin-slice the various qualities instantly. Thin-slicing is a combination of looking at the image in front of us (either on the screen or in a print) and comparing it mentally and intuitively to other excellent prints that we have seen previously—either ours or someone else's (this is why studying with a master and studying great photographs is important).

Watch how it works. Figure 2-1 shows the original image from the camera. The cropping was done visually in the camera and needs no adjustment. Notice immediately, however, that too much contrast blocks out important shadow and highlight details. Contrast can be the first quality that needs to be adjusted in a photo, because the other qualities depend on proper contrast adjustment for harmony. The picture I wanted to make would portray the soft light, tones, and colors of dawn. The picture as photographed was much too contrasty to show this, so my overall impression of how to improve this image meant reducing contrast, making the colors softer, and illuminating the ambient light present with sunrise. These three factors are continually reevaluated during the entire adjusting process.

Figure 2-1: The original image

In Figure 2-2, the overall contrast has been adjusted to provide a proper rendering of the scene, but it still looks a little too dark and needs to be lightened a bit. The lightened result is shown in Figure 2-3.

 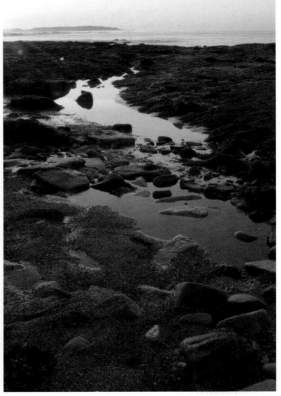

Figure 2-2: The contrast has been adjusted. **Figure 2-3:** The scene has been lightened.

Looking at the local areas of the picture, several areas obviously need to be either lightened or darkened to balance the image. The shadow areas of the rocks need to be lightened and the sunrise in the upper-left corner of the image needs to be darkened. The extreme highlights of the rocks and seaweed need to be lightened to provide a "sparkle." The result is shown in Figure 2-4.

The local color also needs to be addressed. Local color problems are usually about saturation—the local colors are either too intense or not intense enough. In this picture, the yellow of the sunrise needs to be enhanced to balance the deep blue sky. That yellow color needs to be

reflected on all sunlit objects in the image. In other words, I must enhance the effect of the sunrise to make it look correct, as in Figure 2-5.

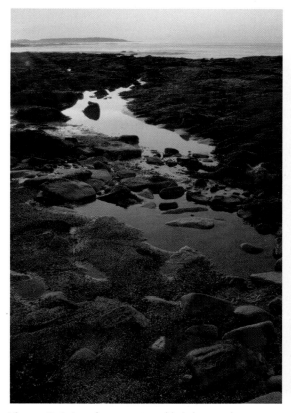

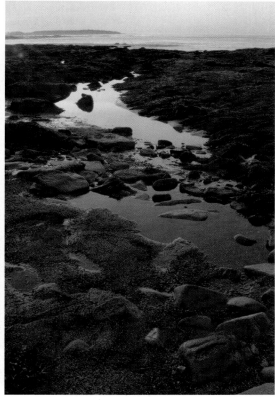

Figure 2-4: Local contrast and brightness have been adjusted.

Figure 2-5: Local color after enhancement

Once the local contrast and color are adjusted, I can get rid of defects—two on the left, just next to the sun's rays, and some in the sky. Figure 2-6 shows the image after their removal.

The picture now needs to be sharpened to enhance the details, but not the sky and the water. Look at the difference between Figures 2-6 and 2-7. (I've oversharpened Figure 2-7 slightly to ensure that it shows up in print.)

Finally, because the contrast or brightness still looks off, I adjust it very slightly without affecting the colors. Here, as you can see in Figure 2-8, I retain the gentle nature of the sunrise, while giving the midtone values a little more separation.

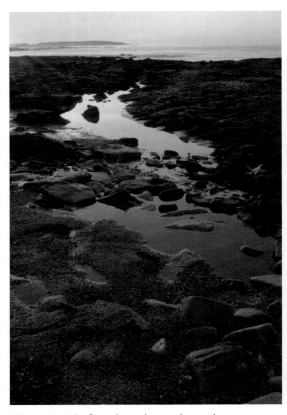

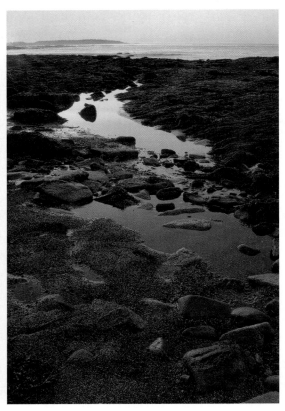

Figure 2-6: Defects have been cleaned up. **Figure 2-7:** The image is sharpened.

So far in this discussion, I've not mentioned anything about Photoshop. I want you to get used to thinking in terms of how the photograph ought to be presented as a whole first, and then worry about how to make the adjustments in Photoshop. Compare the original image in Figure 2-8 to see how all the aesthetic decisions are combined to make an image that shows the soft glow of sunrise. The differences are subtle, but the final result has the "presence" of sunrise.

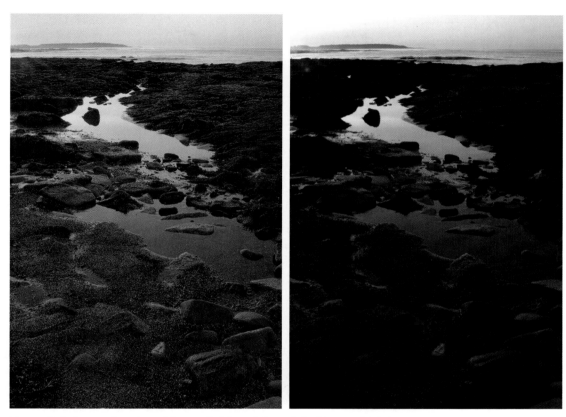

Figure 2-8: Separating the midtones (left), and the original image (right)

Know the Instruments

By now, you understand that the qualities of cropping, contrast, brightness, color, defects, and sharpness of a digital fine print are similar to the instruments of an orchestra, and the photographer is the conductor. Until you become proficient at thin-slicing—being able to see immediately what needs to be done simply by looking at the image—you can make use of some tools in Photoshop that help you in this process. These tools will help you to learn and know these qualities.

Cropping

A good picture is seen and felt as an organized whole, and it is cropping that defines this wholeness or unity, when the original image fails to faithfully capture the photographer's vision. It is the first step toward

creating the "presence" of the photograph. For many photographers, cropping is an ethical as well as an aesthetic issue that must be done in-camera so that the "purity" of the original vision is held in the final image. However, this is not so much an ethical problem, really, as an opinion of the individual photographer.

Suppose, for a moment, that I want an aspect ratio in an image that is twice as long as it is wide—a panorama—but the only camera I have is a 4×5 large format view camera. Obviously I have to crop to get an image that is 2×4. To accomplish this, I can draw a 2×4 frame on the ground glass on the back of the camera and compose through that, rather than taking the whole negative into account. Also, consider that part of an image may not be necessary for the composition, but has to be included in the format to take the picture and be cropped after the image is in Photoshop. Adjusting aspect ratio is the most common reason for cropping. Another reason for cropping is that the photographer saw another picture in the image after it was loaded into Photoshop and used a crop to isolate that picture. Figure 2-9 shows examples of a photograph before and after cropping.

Figure 2-9: Image uncropped and cropped

The real concern, however, is not the secondary considerations of camera format or other frame, but the primary aesthetic reason for cropping in the first place. When we consider that *every image is cropped*, even those we don't crop in-camera, our thinking starts to change from the *technical* act of cropping to the *aesthetic* act of cropping. With this in mind, we can

proceed to the conclusion that it's not the cropping or camera format that is important, but the picture and its unified composition and presence that matter. Once we determine what the composition is aesthetically, we can proceed to adjust the frame to accomplish the composition. Our perspective here is very important. *It is critical.*

How do photographers make correct aesthetic decisions about cropping their pictures? This is not a rhetorical question; it is a difficult and practical one that poses more questions than answers. It involves considerations of both the subject (content) of the image and its structure (form) to bring forth wholeness and presence. This aesthetic decision has been a part of artistic endeavors since the beginning of *art.*

My cryptic answer to this question has been formed from more than 40 years in photography. It has been winnowed by viewing and making hundreds of thousands of photographs; carved out of the rocks of the earth and sculpted by the wind; torn out of suffering and elevated by epiphany. *Authenticity* is the soul of a photographer and it is the driving force from which we all work. It is our authentic vision that makes a photograph work in a way that is true to us as photographers, and not just for someone else's aesthetics. Only we, each one of us, can say what that moment in front of us represents as we click the shutter. No rules apply; only the authentic vision of a photographer grabs our attention and makes us look. So the only question we need to answer for cropping is this: *Is the image authentic?* Authenticity is different from originality. Originality comes out of the human desire to be different. Authenticity comes out of the desire to be oneself. Everything else follows.

Much of my photography centers around the mysteries of the world. Over the years, I've learned that the world gives up its mysteries reluctantly and the work is difficult. By acting out of my desire to find mystery, I am being authentic, being myself. I don't want to be original; I just want to present in a photograph my authentic response to a mysterious moment in front of me. It's not any more complicated than that.

Figures 2-10 and 2-11 show an image taken by the camera and the cropped image that helped me expose the authenticity of the moment when it was taken. Figure 2-10 is the original JPEG file right out of the camera. I took several images of these cowboys roping at a rodeo, but this was the most spontaneous and authentic. I had imagined the image in black and white with a long horizontal format. Figure 2-11 shows the final

crop and black-and-white conversion. The picture was cropped very carefully to fit my vision of the action and motion of the scene, and the long horizontal format helps this effect.

Photoshop's Crop tool may be the simplest, yet most profound, aesthetic device in all digital photography. What gives it that power is how we use it.

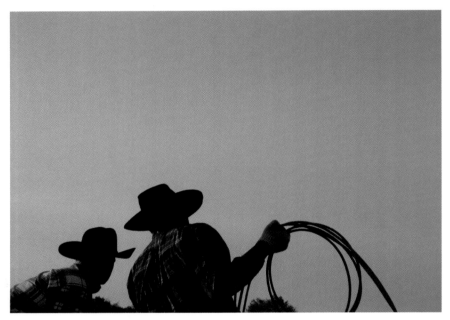

Figure 2-10: Original JPEG camera image

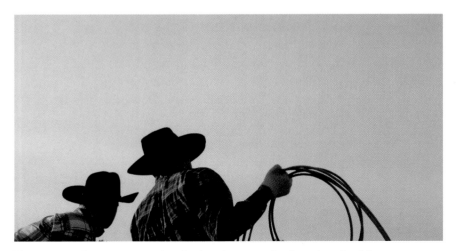

Figure 2-11: Image cropped to fit the photographer's authentic vision

Contrast and Brightness

I deal with contrast and brightness together because they are often confused. In the Adobe Camera Raw (ACR) interface, two sliders are used: one for Brightness and one for Contrast. (The Exposure and Shadow sliders set the highlight value and the shadow value, respectively, so that the image doesn't *clip*, or lose, information.) *Brightness* affects the change (bright or dark) in the overall sense of the light without changing the tonal value relationships between highlights and shadows. Brightness adjustments make an image lighter or darker. The settings you choose are based partly on visual and partly on intuitive evaluations. *Contrast* is the change in the relationships among different tonal values between highlights and shadows. You see either flat contrast or high contrast or somewhere in between. In general, an image with good contrast will show visible texture in the highlights, visible texture in the shadows, and good separation of the midtone values.

By loading an image into the ACR interface, you can adjust Brightness and Contrast settings and see the differences immediately, as shown in Figures 2-12 through 2-14.

Figure 2-12: Default settings for overall brightness and contrast

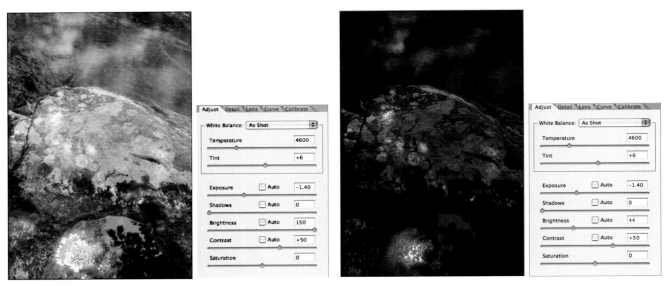

Figure 2-13: Brightness is too high (150); brightness is too low (44)

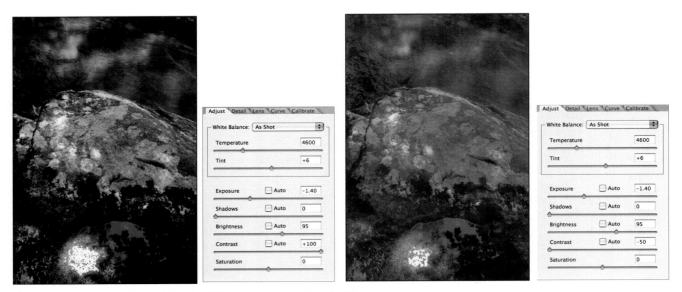

Figure 2-14: Contrast is too high (+100); contrast is too low (−50)

The JPEG workflow for diagnosing brightness and contrast is different from the preceding method but accomplishes the same purpose. Use Levels to evaluate brightness and contrast values, as shown in Figures 2-15 through 2-19.

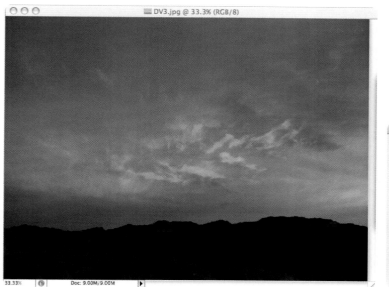
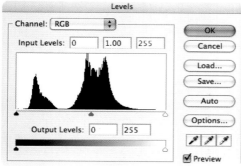

Figure 2-15: Original JPEG file showing default brightness and contrast settings

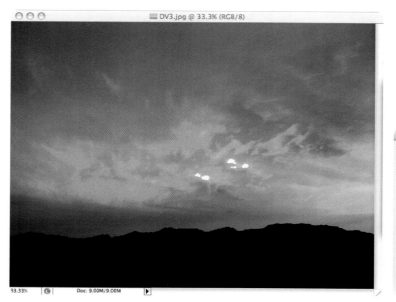
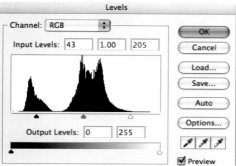

Figure 2-16: Too much contrast; black and white Input sliders are brought in too far.

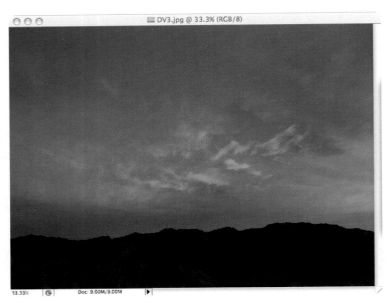

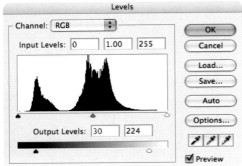

Figure 2-17: Too flat; black and white Output sliders are brought in too far.

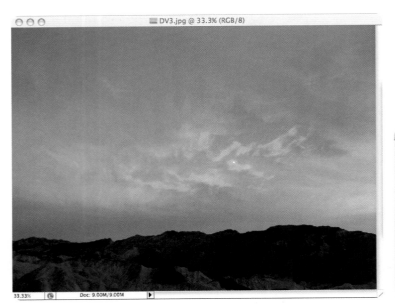

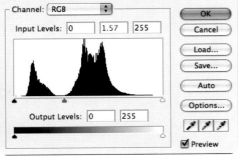

Figure 2-18: Too bright; Input midtone slider is too far to the left.

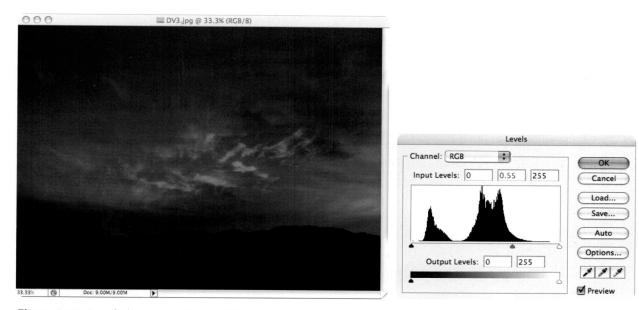

Figure 2-19: Too dark; Input midtone slider is too far to the right.

Color

Color is relative, and Photoshop is not an accurate color-correction tool. These two statements go against the grain of everything we are usually taught about how to "correct color." Accurate color can be made only with the original input file from the camera—in other words, the white balance must be correct at the time of exposure for the image color to be truly accurate. We must begin with accurate color, not create it. There is nothing—*nothing*—in Photoshop that we can do to make color accurate unless it is first captured in the camera.

In other chapters in this book, you learn how to obtain color that matches (or nearly matches) both screen image and print. It's called *color management.* You also learn about color and how to use Photoshop tools to adjust the color of an image. In this small segment, evaluating color in the overall scheme of the print itself is of primary concern. I assume that your monitor is calibrated and that you have accurate color profiles before you begin to evaluate. I am also assuming that you have accurate color-capture files. Color evaluation is worthless without color management.

Note

See Appendix A for information about properly setting up your workstation for color management.

All that being said, let's assume all your color management tools are in place and you have an accurately captured color image as far as white balance is concerned. Well, suppose the white balance is accurate, but it doesn't look right to you (color is relative, remember). Your first clue that the color is strange is that it just doesn't *feel* right. Your simple task is to figure out what color is causing the offending cast or off-color. Once you determine that, you can adjust the color by adding some of the off-color's complementary color (see Chapter 3). If it needs to be muted (less saturated), use its complement. On the other hand, if a color needs to be enhanced (more saturated), add more of the color to itself. This applies to both overall color balance and local color balance.

If you can't figure out what color is off, you can use Photoshop's Variations (choose Image | Adjustments | Variations) to help narrow down the choices.

In Figure 2-20, the beach stones have a blue cast reflected from the sky. If you look at Variations (Figure 2-21), you can see that the photograph that looks closest to the correct color is the More Yellow variation image (located in the upper-right corner of the large box with seven images). Click this image, and the Current Pick image changes to that color variation.

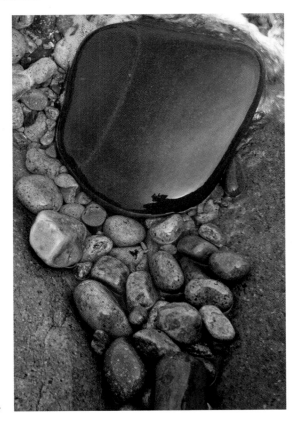

Figure 2-20: The original image

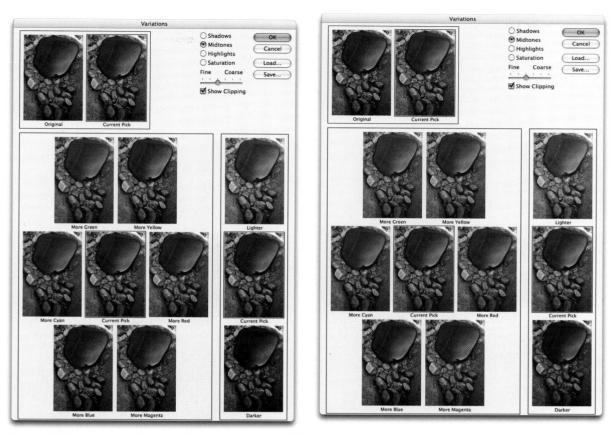

Figure 2-21: Variations showing the default settings (left), and Variations showing the More Yellow choice as the Current Pick (right)

Figure 2-22 shows the effect of adding more yellow to adjust the image. Notice that in the upper right of the Variations window, we have control of the highlights, shadows, and midtones as well as saturation. The slider affects the degree of change for the six colors surrounding the Current Pick. Variations helps many beginning Photoshop users get the color balance right in a picture, but for advanced control we'll want to use Levels, Curves, Color Balance, and any of the other color tools discussed in Chapter 3. Variations is a good diagnostic tool for finding *overall* color casts and adjusting them.

Figure 2-22: Image with the color adjusted

In the example of the sunrise photograph at the beginning of the chapter, I showed how I enhanced the yellow of the sunrise. Figures 2-23 through 2-25 show how I used Hue/Saturation (Image | Adjustments | Hue/Saturation) to adjust the color. In the Edit field (Figure 2-24), I chose Yellows and increased the Saturation slider to enhance the yellow and the feeling of sunrise.

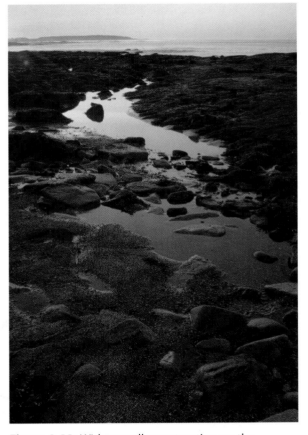

Figure 2-23: Without yellow saturation on the highlights

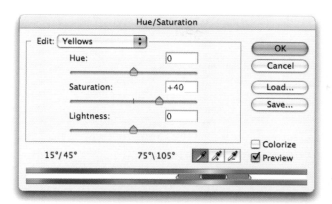

Figure 2-24: Hue/Saturation dialog box with Edit set to Yellows and the Saturation slider moved to the right (to increase saturation)

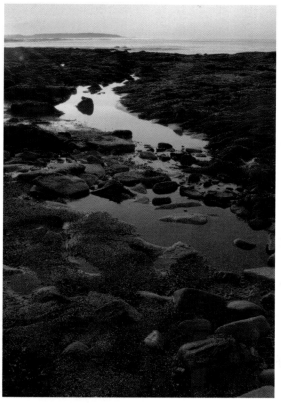

Figure 2-25: With yellow saturation on the highlights

Remember that the first thing you need to do when evaluating color is to find the color(s) that needs to be adjusted. Using ACR, you can get so close to the correct white balance and color of the photograph that you often do not need to adjust it more using Photoshop.

Defects

A *defect* is any visible spot in the picture that does not represent the original image as seen through the camera (non-image forming content). This could include dust spots, scratches, and lens flare. A defect distracts from the aesthetic presence of the image. The best way to find defects is to look at the image in Photoshop or ACR at 100 percent (actual pixels). If you eliminate those defects at 100 percent, you won't be able to see any of

them in the print. If you try to eliminate defects at less than 100 percent, they might show up in the print.

To examine the image at 100 percent, open the photograph and double-click the Zoom tool (next to the hand) in the Photoshop Toolbox. Look for defects by holding down the SPACEBAR and dragging with the Hand cursor. Figure 2-26 shows several ugly spots in the light-colored areas of the image from dust on the camera's sensor. You can use the Clone tool, the Healing brush, or the Spot Healing brush in the Toolbox (Figure 2-27) to remove the defects (Figure 2-28).

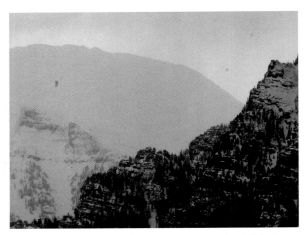

Figure 2-26: Dust on the camera sensor is visible in the sky.

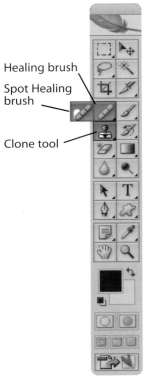

Healing brush

Spot Healing brush

Clone tool

Figure 2-27: Clone tool, Healing brush, and Spot Healing brush

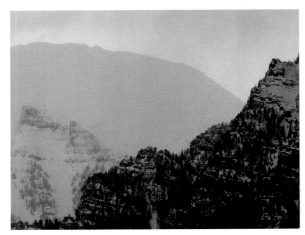

Figure 2-28: Defects removed

The noise defect can easily be seen in even-toned areas such as the sky, but it is especially noticeable in shadows. I usually look at the shadows of a digital image file at 300 percent to evaluate noise properly. In RAW files, I check for any noise by selecting the Detail tab in ACR and moving the Luminance Smoothing slider. Viewing the image at 300 percent with the slider all the way to the left, I can see any noise if it's there. If noise is visible, I move the slider to the right until it disappears.

In Photoshop CS2, you can evaluate noise in JPEG images by choosing Filter | Noise | Remove Noise. Another excellent and highly recommended noise evaluation and correction tool is Noise Ninja. Figure 2-29 shows noise removal with one-step Noise Ninja.

Figure 2-29: Image at 300 percent with noise (left), and noise removed with Noise Ninja (right)

Sharpness

Sharpness, as well as detail enhancement, needs to be evaluated at 100 percent (actual pixels)—the same magnification we used to evaluate defects (open the image and double-click the Zoom tool in the Photoshop Toolbox). Evaluating sharpness is tricky at the beginning of the workflow because the image is definitely going to need it after the workflow. (Some photographers advocate sharpening after each stage in the workflow, but I am not among them—mainly because there is a tendency to oversharpen.)

Sharpness is difficult to evaluate, because adjustment of sharpness on the screen looks different than it does in the print.

Note

The workflow in this book deals with contrast optimization and detail enhancement first. Some photographers might consider these procedures to be sharpening techniques, but the mathematical algorithms behind optimization and detail enhancement are different from those of sharpening. Optimization and detail enhancement algorithms were borrowed from NASA software that fixed images taken by the Hubble telescope—the software put the detail back into the fuzzy images the telescope first produced. Sharpening, in this workflow, occurs after everything else is done—at the end. For this reason, I rarely look at the Sharpening slider in ACR (in other words, I leave ACR Sharpening set at its default).

If you own Optipix software, Safe Sharpen used with the Photoshop Fade command (Edit | Fade) works very well for evaluating sharpness in both JPEG 8-bit and Photoshop or TIFF 16-bit files. Pixel Genius Photo Kit Sharpener and nik Sharpener Pro are also excellent sharpening plug-ins with which you can evaluate and adjust sharpening at the end of the workflow before printing. If you don't have Optipix, you can use Photoshop's Unsharp Mask (Filter | Sharpen | Unsharp Mask), with Amount set to 200, Radius set to 0.3, and Threshold set to 0, and then use the Fade command to back off if the effect is too much.

After all of the workflow is complete and you have flattened the image for printing, you can evaluate the picture sharpness at 100 percent (actual pixels). You can apply either Safe Sharpen or Photoshop Unsharp Mask, and then back off with the Fade command if necessary. Then you make a test print to evaluate the sharpness. If the print is too sharp, you can back off on the sharpening; if it's not enough, you can repeat the process with Unsharp Mask or Safe Sharpen. Both of the settings in Safe Sharpen and Unsharp Mask were designed to work with the vast majority of pictorial images that photographers make, so they should come pretty close on the first try.

Figures 2-30 through 2-33 show various sharpening effects.

Figure 2-30: Unsharpened

Figure 2-31: Safe Sharpen

Figure 2-32: Unsharp Mask

Figure 2-33: Too much Unsharp Mask leads to blown-out edges, an effect called *blooming*.

Evaluate Continuously

By evaluating continuously, we inspire ourselves to probe the depths of what an excellent digital fine print might be. Printing well requires a mentally strenuous effort. Juggling the qualities of a digital fine print in one's head while working to unify the image into presence requires disciplined evaluation, skill, experience, time, and vision. The commitment is lifelong.

The goal is a unified presence of light, substance, subject, and emotion sought from the heart. It begins with one movement and then another, and another, and another—one positive quality at a time enhanced to bring out the whole and essence of the subject. If we seek unity—wholeness—in the presentation, the presence will come. By continually evaluating the small and insignificant, by seeing and feeling the whole, we find, paradoxically, the spirit of the print.

Working with Luminosity and Color in Photoshop

About 500 years ago, Leonardo da Vinci invented a scheme of color shading that changed painting forever. Before Leonardo, most painters used black paint to darken shadows in oil paintings, thereby making them dull and lifeless. Leonardo discovered, by carefully looking at nature, that objects did not shade into black but into a deeper tone of the color represented. He also noticed that the highlights of an object tended to be a purer form of the base color and did not shift into white. In his own paintings, he created a series of shades devoid of black—his works of art were full of color and life that had never been seen before. This form of color painting that keeps color saturation uniform, called *chiaroscuro*, dominates representational painting even today.

Uniform chroma, as the phenomenon of chiaroscuro is called in color science, has been investigated and described by all the major color systems of the nineteenth and twentieth centuries. Especially in the Oswald and Munsell color systems (whose theories explain most artists' use of color), much care was taken to describe and orient colors so that they appeared as a natural progression, as we see them in nature. The use of uniform chroma, known by all painters throughout the world either practically or intuitively, allows them to eliminate the muddy and dull shadows of a painting by attenuating or discarding the use of black and white to darken and lighten colors, respectively. Uniform chroma is achieved when a darker color of the base color is used to darken (shade) and a lighter color of the base color is used to lighten (tint).

Because of the nature of the photographic process, we are at the same point in photographic history as Leonardo was when he created chiaroscuro. Until recently, color photography has been shackled to the black-and-white contrast ranges of films and digital sensors. With the exception of the Dye Transfer Process, which is no longer available, photographers found it virtually impossible to control the contrast and attendant loss of color in the highlights and shadows inherent in color film. They were at the mercy of a black-and-white process that controlled the mixture of the color dyes via dye couplers in the film. This dilemma was obvious to all photographers who witnessed shadows and highlights in their color prints that were much duller than those in nature.

The controls in Adobe Photoshop, combined with the color pigment inks of modern inkjet printers, have enabled photographers to keep chroma

uniform and produce prints that are now considered finer than original silver or color dye prints, and they are more archival. One of the most important functions of this new set of technologies is the ability to control chroma (saturation) in Photoshop independently of color and brightness. The new Epson printers with archival color pigment inks combine with these Photoshop controls to bring us very high quality output.

In addition, the controls of hue, saturation, and brightness (luminosity) are highly developed in Photoshop, as you shall see shortly. Various means are available for controlling not only overall color and color casts, but individual local colors as well.

Color has three characteristics, which we use to control color in Photoshop images:

- **Hue** The hue of a color is the name of the color—such as red. Hue is the easiest aspect of color for most people to recognize.
- **Saturation (also called chroma or intensity)** The saturation (chroma) is the intensity of a particular color (red), ranging from low (pink) to high (scarlet).
- **Brightness (also called luminosity or value)** The brightness of a color is its black-and-white component—the grayscale value from white to black if the hue were removed. Black-and-white photographers who use the Zone System are familiar with brightness or value.

The only way to control the problem of uniform chroma is to control the dynamic range of the digital file. When the contrast is normal (about five stops of detail from highlight to shadow), uniform chroma is not problematical and can be handled by most digital cameras and Photoshop. When the contrast range exceeds normal, the difficulty of keeping chroma uniform starts to become obvious. In contrasty situations that exceed five stops, the solution is to make two exposures, one for the shadows and one for the highlights, and combine these two images in Photoshop using Optipix (a Photoshop plug-in from www.reindeergraphics.com) or Photoshop HDR (a tool existing in Photoshop) and other methods, thus extending the dynamic range and giving better color and detail. *It is manifestly important to understand that controlling the dynamic range, the textural range, and the luminosity (brightness) component of an image (in either color or black and white) is the basic key to all successful images.*

The Problem of Uniform Chroma

Making colors with more saturation in the highlights and shadows is an age-old artistic problem. Leonardo da Vinci discovered the solution by using purer colors in the shadows and highlights rather than black to shade shadows and white to tint highlights. The problem was solved for painters, who can add paint any place they want. However, photographers have always been tied to the black-and-white grayscale, in which shadows are blocked and highlights are washed out.

In the following illustration, we see the detail range of a typical digital SLR camera (in this case the Nikon D2X), showing that the spread of detail goes from about two stops below middle gray to two stops above middle gray. (The Roman numerals represent Zone System terminology for traditional black-and-white photographers.) Each of the patches varies by one stop in exposure. Below the grayscale are photographs of the GretagMacBeth ColorChecker, showing how exposure affects the saturation. At one stop above and below middle gray, the good saturation of color is almost gone, and in two stops above and below middle gray, the saturation is gone altogether.

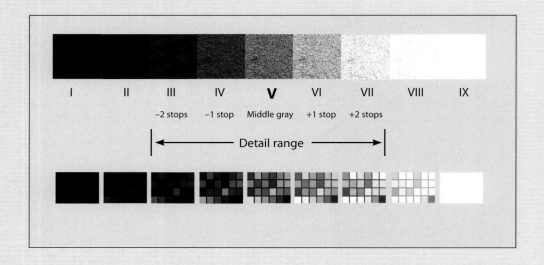

This effect can be seen graphically when we take a photograph that is beyond the detail range of the film. At right is a photograph taken with an average reading and exposed with one frame.

Below is the same scene, captured with two exposures, one stop more and one stop less than average exposure, and blended together in Photoshop using Optipix. Notice how much more color the shadows and highlights display. This is uniform chroma (saturation). Photoshop HDR may also be used for this purpose. Either one of the saturation tools, the Sponge tool, or the History brush technique, explained in Chapter 9, can further enhance the saturation in the highlights and shadows.

Underexposed one stop

Over- and underexposures blended

Overexposed one stop

The Colors

Photoshop mixes light, not paint. To many people who know how to mix paint or colorize with any pigment on paper, the fact that Photoshop mixes light is not intuitive. The printers we work with print with pigments, but on the computer monitor we work with light. Photoshop uses six colors to make all of the colors we see in an image: red, green, blue, cyan, magenta, and yellow (Figure 3-1).

| Red | Green | Blue | Cyan | Magenta | Yellow |

Figure 3-1: The colors of Photoshop

It is important to know some basic things about these colors. Cyan, for instance, is an equal mixture of blue and green (Figure 3-2), yellow is an equal mixture of red and green (Figure 3-3), and magenta is an equal mixture of blue and red (Figure 3-4). The common color to yellow and magenta is red, the common color to yellow and cyan is green, and the common color to cyan and magenta is blue. Each of the colors has an opposite, or complement, which, when added together equally, makes a neutral black, white, or gray, depending upon the brightness of each. Cyan (blue and green) is the complement of red (Figure 3-5), magenta (red and blue) is the complement of green (Figure 3-6), and yellow (red and green) is the complement of blue (Figure 3-7).

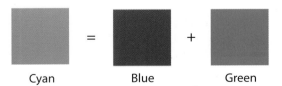

| Cyan | = | Blue | + | Green |

Figure 3-2: Cyan is an equal mixture of blue and green.

| Yellow | = | Red | + | Green |

Figure 3-3: Yellow is an equal mixture of red and green.

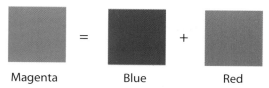

Magenta Blue Red

Figure 3-4: Magenta is an equal mixture of red and blue.

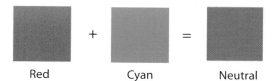

Red Cyan Neutral

Figure 3-5: Red is the complementary color of cyan. If they are mixed together equally, neutral results.

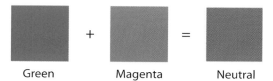

Green Magenta Neutral

Figure 3-6: Green is the complementary color of magenta. If they are mixed together equally, neutral results.

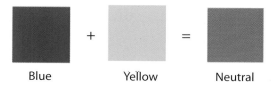

Blue Yellow Neutral

Figure 3-7: Blue is the complementary color of yellow. If they are mixed together equally, neutral results.

If we arrange these six colors in a way that they can all relate to one another, we form a circle (the color wheel), with yellow at the top, representing the sun, and blue (yellow's complement) at the bottom, representing the sky (see Figure 3-8). The sun and the sky are the two main light sources of daylight, our most common and familiar forms of illumination. Red and green go on either side of yellow (because they are both common to yellow), and cyan and magenta go on opposite sides of blue because blue is their common color. N represents neutral. If two complementary colors are mixed along the straight line, the color changes to neutral in the middle of the circle. Colors mixed with two adjacent colors cause a blend between the two.

Figure 3-8: The color circle (or color wheel)

If you thoroughly understand and apply these basic principles of color, you'll have no problem with diagnosing and adjusting color problems in Photoshop.

The Qualities of Color

Photoshop allows you to adjust the three qualities of color: hue, saturation, and brightness (HSB). Recall that hue is the name of the color, such as red or blue. Saturation is the color's purity and is also referred to as intensity or chroma. Brightness, or luminosity, is the black, gray, and white component, or value, of color.

Hue

Hue is important to photographers because it allows us to determine what color is producing a color cast in a photograph. The best way to get the desired hue is to choose the proper white balance during image capture (while taking the photograph). If that fails, a color cast—an overall veil of one or more colors—can appear in the photograph. Often, in order for the color to look right to us, we have to eliminate the cast from the picture using Photoshop, and it is therefore very important to identify the hue of the off-color accurately. We can then adjust that hue by using its complementary

color. Whenever we change the overall hue in a photograph, we change the overall white balance. For example, Figure 3-9 shows a hazy day in the Great Smoky Mountains. The image shows an overall yellow cast. Figure 3-10 is the same image corrected using a blue filter.

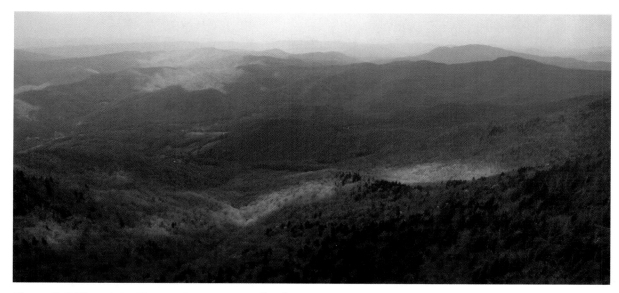

Figure 3-9: The original image shows an overall yellow cast.

Figure 3-10: Here is the same image, corrected with a blue filter.

Saturation

Saturation allows us to change the intensity of the hue, either in the entire photograph or in local areas within it. This is useful for enhancing (saturating) colors that are dull or desaturating them because they are too colorful. The saturation tools in Photoshop also offer great control over the immense problem of uniform chroma caused by the black-and-white tonal scale of the image (brightness or luminosity). In the photographs of razor clams (Figures 3-11 through 3-13), you can see the various effects of saturation and their correction with Hue/Saturation (Image | Adjustments | Hue/Saturation).

Figure 3-11: This image is far too saturated.

Figure 3-12: The same image, desaturated to look better

Figure 3-13: The same image, desaturated 100 percent

Brightness

The photographer who has control over brightness (which I often call *luminosity*), or the grayscale quality of color in a photograph, has won most of the battle in getting the photo to look right. One of the rites of passage in traditional photography is understanding and controlling a black-and-white photograph before tackling color successfully. I'll show in

this book that the same understanding of black-and-white luminosity is still the major hurdle for photographers struggling with digital photography. The ability to see and apply many nuances of gray all the way from the deep shadow areas to the very faintest highlights—grays that are distinct and well separated—is one of the keys to an excellent photograph. Again, it is important to learn and apply the essence of grayscale luminosity to a photograph.

Why Luminosity Is Important

Luminosity is represented in a photograph by tones of black, white, and gray. *Luminosity is light.* It represents all that we can see about the world we photograph. Every object, event, and mood depends upon visible light represented by luminosity in the photograph.

Luminosity is important to visualize when we are taking a picture, when we are transforming it in Photoshop, when we calibrate our monitor, and when we print. Because of the nature of visual perception, hue and saturation are processed separately from luminosity in our brains, and we must forcibly separate luminosity and train ourselves to see it to accomplish the quality we desire in a digital fine print. A good print starts with seeing the luminosity of a scene and ends with it.

Figure 3-14 shows a photograph of the Matterhorn I made when I was 19 years old in 1964 with a Kodak Instamatic camera. This photograph has been one of my greatest teachers. I have kept it by my bedside for years, and I've learned more about photography and the world from it than from all the hundreds of books or teachers or photographs I've known. It's largely important because I made it before I knew anything at all about photography or f/stops or film speeds or great photographers. It is pristine vision. The camera was the cheapest Instamatic Kodak made (about $10, if I remember correctly). The film came in a cartridge that you dropped in and the image size was 1 inch by 1 inch. I knew at the instant I snapped the shutter that the photograph was a good one, at least visually. I have spent more than four decades trying to figure out why, and I have learned much. One of the most important of those lessons I've learned is about light and how to photograph it. That morning, looking at the Matterhorn, I discovered luminosity.

Figure 3-14: The Matterhorn, 1964. Kodak Instamatic camera and Ektachrome film. Exposure unknown.

The light in this photograph has always been special to me, and I continually strive to understand why. The light seems to be a part of the scene and yet not a part of it. How do we see this and how do we, metaphorically, put ourselves in the path of its beam? The answer, for me, came from the aesthetic interpretation of two concepts that describe light: *ambient light* and *reflected light.*

Ambient light is the light from a light source (in this case the sun) that falls upon the subject we are photographing. Reflected light is the light reflected from the subject (in this case the Matterhorn) we are photographing. The quality of both these types of light is seen and represented differently in the black-and-white luminous tones of a photograph. Two great men wrote about this peculiar phenomenon:

Dr. Edwin Land, from the Polaroid annual report (1978):
The most extraordinary of man's artifacts in the reconstruction of reality is the black and white image comprising, of course, a series of grays. It can be shown that in seeing color, objects are separated out from each other by the preferential *efficiency* of the surface of one object or another for reflecting light of one wavelength or another and that this preferentiality remains intact irrespective of the variation in time and place of the illumination on the object from the world around it. Black and white photography generates, as it were, a substitute world: light of the same wavelength composition comes to the eye from any part of the scene. Thus preferentiality for reflecting at different wavelengths is absent and cannot be used to designate objects. Rather only the difference from object to object in the efficiency for reflecting a uniform mixture of wavelengths can be used. Here comes in the miracle. The enormous variations in illumination of the objects by the world around them have led to enormous variations in the amount of light reaching one object or another in a random way, so that portions of the photograph delineating dark objects may send to the eye more light than portions of the photograph delineating white objects. In short, the photograph is two entirely different kinds of report transmitted to us by what appear to be mixed languages, the language for delineating objects and the language for displaying illumination.

There have not been many great photographers in history, but the great ones usually turn out to be masters of the vocabulary of these two utterly different languages in black and white photography. For most would-be photographers these languages are mixed together and never disentangle, like the babble of voices at a cocktail party. The breathtaking competence of the great photographer is to cause the object of his choice to be revealed with symphonic grandeur, meticulous in detail, majestic in illumination.

Ansel Adams, from Natural Light Photography *(1952):*
Light, to the accomplished photographer, is as much an actuality as is substance such as rock and flesh; it is an element to be evaluated and interpreted. The *impression* of light and the *impression* of substance which are achieved through the careful use of light are equally essential to the realistic photographic image…. To utilize it fully you must know how to evaluate its intensities and qualities, not only in their effect on sensitive emulsions, but also in relation to the intangible elements of insight and emotion that are expressed in a good photograph. A certain esthetic philosophy is involved; something more than the physical conditions of light and exposure…. The chief problem is to preserve the *illusion of light* falling upon the subject. A print intended to convey an emotional impression may differ from a normal photographic record.

Both Land and Adams are discussing in general terms the two types of light that a photographer has to deal with: the light reflecting from a subject (reflected light) that causes its texture and form, and the light falling on the subject (ambient light) that causes the overall "mood" or aesthetic character of the image. The quality of light both reflected from the object and the ambient illumination falling on the entire scene are represented in the photographic print by luminosity alone.

In my photograph of the Matterhorn I see these two types of light distinctly, yet they are blended into one as finest gold. I see the dominant shape of the mountain formed by the variations of light and dark. I see the middle ground ridge with its black horizontal shape. And yet, a softness to the image is created by the enveloping skylight of dawn and the brilliant highlight on the mountain. I've come to sense these things when I photograph, and when they come together in that representational symphony of light and crystal, I feel the earth as the ancient Greeks must have *experienced* it: earth, air, fire, and water.

Ambient and Reflected Light

Look at the following images and try to discern the differences between ambient and reflected light. They are intentionally not labeled. A photograph usually contains both types of illumination, but one will usually dominate the other. Think of reflected light as defining an object and ambient light as a "feeling" or a "wash" of light over the subject. Absolutely defining such aesthetic truths is impossible. By engaging in this simple exercise intuitively, we see that luminosity has *meaning*. A visual vocabulary of tonal value and luminosity in black-and-white and color photographs is created by the action of light alone, independent of content. The answers to any questions about luminosity must be treated as a continually unsolved riddle that always changes and that offers us endless possibility in the authentic response of expression in a photograph.

(continued)

Ambient and Reflected Light *(continued)*

(continued)

57

Ambient and Reflected Light *(continued)*

Visualizing and Controlling Luminosity

Taking time to visualize and control the luminosity in a photograph will pay rich rewards in the print. The first tool that I use for this purpose is an item borrowed from traditional photography that helped photographers visualize a scene in black and white before taking the picture—a Kodak Wratten 90 monochromatic viewing filter, shown in Figure 3-15. The filter itself is greenish yellow, but it cancels out color and turns the world into a monochromatic view that shows the contrast relationships and tonal mergers that will occur in black-and-white photographs. This filter is also used extensively in the motion picture industry for the same purpose. The "90" helps us to see a world that we have trouble visualizing. It is available in many forms, from the original Kodak gel to specially made viewers from Calumet, Harrison & Harrison, and Tiffen. Figure 3-16 shows the original color image, and Figure 3-17 shows the image as seen with the 90 viewing filter.

Figure 3-15: Kodak Wratten 90 monochromatic viewing filter

Figure 3-16: Original photograph of leaves in color

Figure 3-17: Leaves shown as viewed through the 90 monochromatic viewing filter

When I study the scene in front of me for luminosity using this filter, all I have to do in Photoshop, if I like what I see through it, is draw the Saturation slider in Adobe Camera Raw to –100 (which desaturates the image and shows only the luminosity), and I'll usually achieve a decent black-and-white (luminosity) image right off the bat (see Figure 3-18). After getting a good luminosity image, I either keep it that way for a black-and-white print, or I'll draw the Saturation slider back to 0 for a color print. With this simple tool and correction, you can see that luminosity is the key to controlling many important things in the image: shadow detail, highlight detail, midtone separation, and uniform chroma.

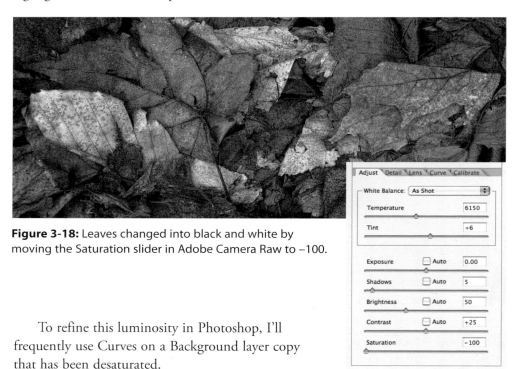

Figure 3-18: Leaves changed into black and white by moving the Saturation slider in Adobe Camera Raw to –100.

To refine this luminosity in Photoshop, I'll frequently use Curves on a Background layer copy that has been desaturated.

How to Use Color in Photoshop

Photoshop uses the six colors and the three qualities of color to create all the colors we see in a photograph. The basic strategy is to adjust brightness

(luminosity) first, define the hue of the color second, and adjust its saturation last. The sequence is important:

1. Luminosity
2. Hue
3. Saturation

 Saturation depends on the hue, and hue, in turn, depends upon luminosity. Luminosity controls the whole ballgame. Let's look at how some of Photoshop's tools use color in similar, yet notably different, ways.

Adobe Camera Raw

To work with color and black and white in Adobe Camera Raw (Figure 3-19), first move the Saturation slider to –100 and adjust Exposure, Shadows, Brightness, and Contrast—in that order—as shown in Figure 3-20. For black-and-white images, this is all you really need to do if you've used the 90 monochromatic viewing filter correctly. For color, slide Saturation back to 0 and adjust the White Balance (if necessary). This should take care of a color photograph. In Figure 3-21, I've adjusted the luminosity (Exposure, Shadows, Brightness, and Contrast sliders) first, but didn't need to adjust the hue in this image because the White Balance looked okay. The saturation controls I'll leave for local adjustment in Photoshop.

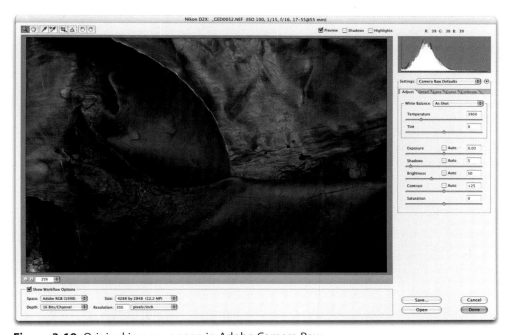

Figure 3-19: Original image as seen in Adobe Camera Raw

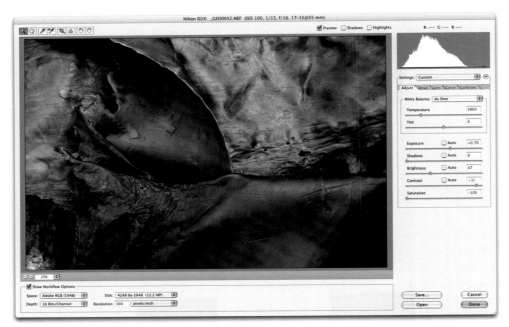

Figure 3-20: Saturation is set at –100 for adjusting luminosity. This will also form the basis for the black-and-white image.

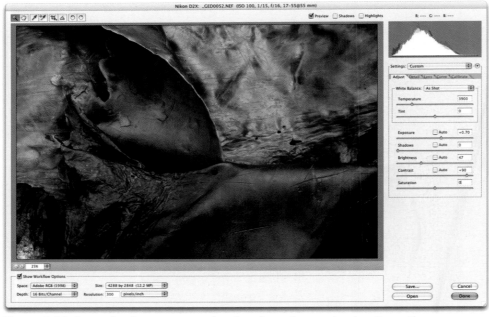

Figure 3-21: Saturation is now returned to 0 to show the new luminosity on the color image.

Color Balance

The Color Balance window (in Photoshop choose Image | Adjustments | Color Balance or ⌘-B in Mac/CTRL-B in Windows), shown in Figure 3-22, displays six colors paired with their complements in sliders. If you move a slider from its neutral middle position, the overall image changes according to the named color. Color Balance enables you to work on the shadows, highlights, or midtones for precise control in those areas. Choosing Preserve Luminosity allows you to increase or decrease luminosity. If you leave this box unchecked, only the overall color changes. Color Balance is very useful for balancing an overall color cast in a photograph. (See the Chapter 8 sidebar, "Fixing a Slight Color Cast.")

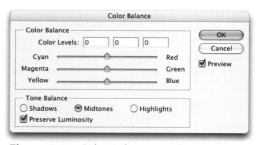

Figure 3-22: Color Balance window

Levels

The Levels tool (Image | Adjustments | Levels or ⌘-L/CTRL-L), shown in Figure 3-23, adjusts both overall luminosity and color together. On the RGB channel we can adjust the overall luminosity, and on the individual Red, Green, and Blue channels we can adjust individual colors. Note that the Red, Green, and Blue channels imply that the complementary colors of these channels are also present, so that the six colors are all represented. By moving the Input and Output sliders on each individual channel, we can adjust the individual colors and their complements.

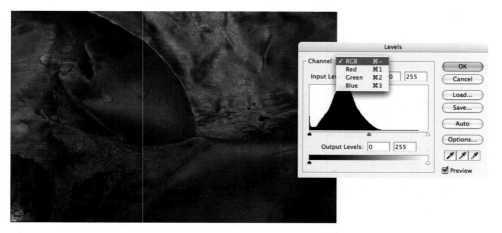

Figure 3-23: Original image showing RGB, Red, Green, and Blue channels. The presence of Red, Green, and Blue implies complements of Cyan, Magenta, and Yellow.

Levels' Auto Color Correction function is also very powerful for getting rid of color casts. Click the Options button in the Levels window to open the Auto Color Correction Options window (Figure 3-24). Click the Find Dark & Light Colors radio button, select the Snap Neutral Midtones checkbox, set both the Shadows and Highlights Clips to 0.10, and check the Save As Defaults checkbox. Then, when we click Auto in the Levels window or choose Image | Adjustments | Auto Color in the Photoshop menu, this auto correction setup will be used to make a fairly good color balance adjustment on most images. (See Chapter 8.) Figure 3-25 shows these settings applied to the original image from Figure 3-23.

Figure 3-24: The Auto Color Correction Options window in Levels with settings for a relatively good color balance adjustment

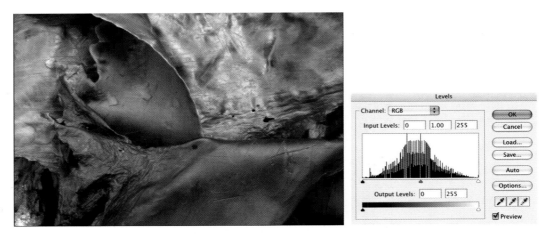

Figure 3-25: Adjusted image reflecting the Options settings changes

Curves

Curves (Image | Adjustments | Curves or ⌘-M/CTRL-M) is similar to Levels in that it adjusts both luminosity and color, either overall on the RGB channel, or individually on each channel. Curves, however, offers more control than Levels and helps to adjust local areas in an image better than Levels. Think of Levels as an overall adjustment tool and Curves as a fine adjustment tool.

To adjust overall luminosity (brightness and contrast), work only on the RGB channel (Figures 3-26, 3-27, and 3-28). To make saturation adjustments that include both an individual color and its complement, work on the Red (Cyan), Green (Magenta), or Blue (Yellow) channel (Figures 3-29 through 3-31). It is important that you understand that in both Levels and Curves you are adjusting the luminosity of the colors on the RGB channel and the overall saturation of the channel color and its complement on each individual channel.

Figure 3-26: Original image with Curves window

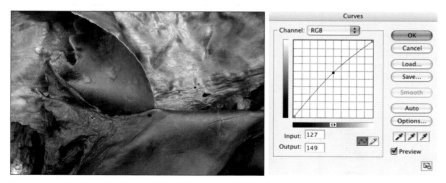

Figure 3-27: Increasing luminosity on the RGB channel

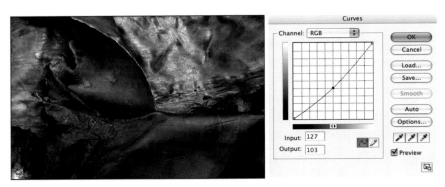

Figure 3-28: Decreasing luminosity on the RGB channel

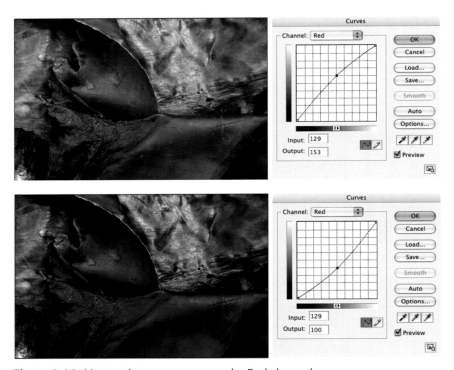

Figure 3-29: More red vs. more cyan on the Red channel

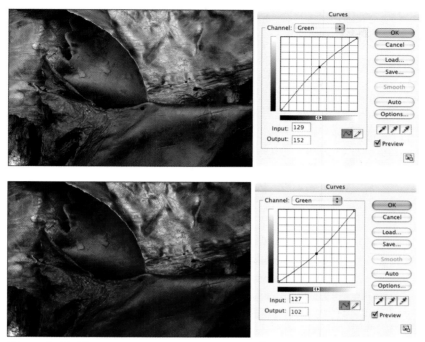

Figure 3-30: More green vs. more magenta on the Green channel

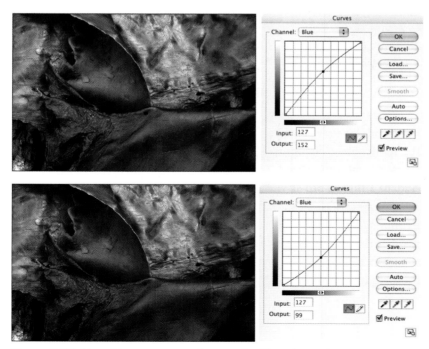

Figure 3-31: More blue vs. more yellow on the Blue channel

Hue/Saturation

Hue/Saturation (Image | Adjustments | Hue/Saturation or ⌘-U/CTRL-U) allows you to control the saturation of each of the six individual hues as well as all of them together (Figure 3-32). In the Master channel, you can control the saturation of all of the colors at once by moving the Saturation slider to the right to increase the saturation (Figure 3-33) and moving it to the left to decrease the saturation. Moving the Saturation slider all the way to the left creates a black-and-white image (Figure 3-34). You can also choose individual channels from the Hue/Saturation window's Edit: Master drop-down list and even refine what color range you want to specify by clicking the Eyedropper tool on the color in the picture you want to change. I usually leave the Hue and Lightness sliders alone in this window because I can control them much better with other tools. You can think of this tool as the "Saturation" tool for ordinary picture editing.

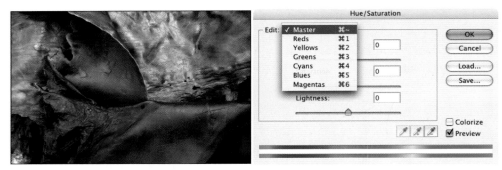

Figure 3-32: Hue/Saturation showing the colors from the Edit: Master drop-down list

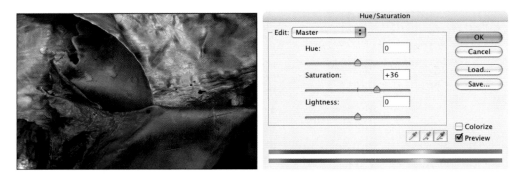

Figure 3-33: Increased saturation with the Saturation slider to the right

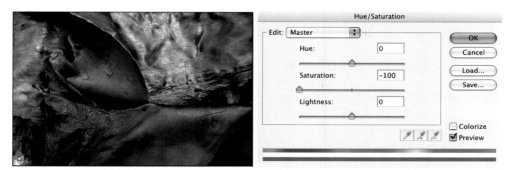

Figure 3-34: Completely desaturated image

Photo Filter

Photo Filter (Image | Adjustments | Photo Filter) is especially useful for color cast and white balance adjustments in JPEG or TIFF workflows (images that originally did not exist as RAW files). Using this tool requires very careful diagnosis of the color that needs to be corrected, and your knowledge of the color wheel, the colors, and their complements pays big dividends here. All six colors are represented under the Filter button, as well as others that you will find useful in traditional photography for correcting color casts.

Remembering that luminosity should be adjusted first, you create a Photo Filter adjustment layer by clicking the Adjustment Layer icon (the half moon) at the bottom of the Layers palette and choosing a filter that seems to be the opposite of the color you're trying to adjust. You can adjust the slider all the way to the left to see no change and all the way to the right to see the maximum change you can make with that filter. Always check the Preserve Luminosity checkbox and get as close as you can. If the color still seems to be off, you can make another Photo Filter adjustment layer, diagnose the color that is off, and use the complementary filter to adjust it. This is a visual process and it takes a little practice.

Figure 3-35 shows an image with a cyan/blue cast. Figure 3-36 shows the cast corrected by using a yellow/orange filter.

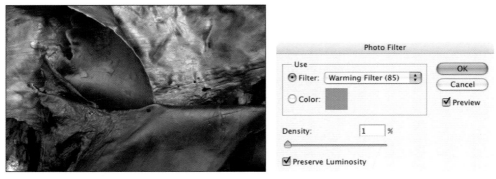

Figure 3-35: Image with cyan/blue color cast

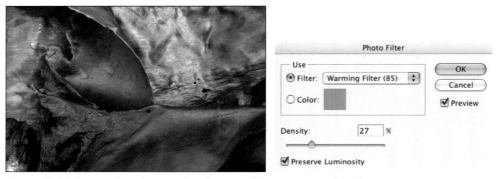

Figure 3-36: Image showing a yellow/orange filter to correct the blue cast.

Sponge Tool

Although I don't advocate using the Burn and Dodge tools in the Photoshop Toolbox, the Sponge tool (Figure 3-37), which is in the pop-up along with the Burn and Dodge tools, is very useful in applying saturation changes to local areas with a brush. In fact, it ought to be renamed the Saturation tool. You can choose one of two Modes in the Photoshop Options bar when you select the Sponge tool—Saturate or Desaturate (Figure 3-38)—and you can control the intensity of the saturation effect by adjusting the Flow setting in the Options bar similar to the way you adjust opacity on a layer (Figures 3-39 and 3-40).

Sponge tool

Figure 3-37: The Sponge tool in the Photoshop Toolbox

Figure 3-38: Options bar showing Saturate and Desaturate Modes and the Flow field

Figure 3-39: Photograph before applying the Sponge tool

Figure 3-40: The same image showing the Sponge tool brushed to increase saturation locally in the upper-right quarter of the picture. The effect is exaggerated.

The Sponge tool, along with Hue/Saturation and the History brush technique described in Chapter 9, puts photographers on the same level as painters and allows us to control the problem of uniform chroma that has been so vexing since the 1930s, when color photography was invented. It represents a major change in how photographers work with color.

PART II
THE WORKSHOP

Input, Copy, and Crop: Workflow for RAW Files

This chapter and Chapter 5 introduce two workflows. You will use *either* the workflow described in this chapter *or* the one described in the next chapter, depending on the nature of your input. If you are starting with RAW files, you can use the workflow in this chapter and skip Chapter 5. If you are starting with JPEG files, you can skip this chapter and go on to Chapter 5. For either type of input, you will then proceed with the workflow in Chapter 6.

Here's what you will learn and adjust in this chapter:

- Transferring an image from the camera to the computer safely
- Using Adobe Camera Raw to make preliminary overall contrast, brightness, and white balance (hue) adjustments to RAW files and prepare them for optimizing in Photoshop
- Cropping in Adobe Camera Raw
- Copying the raw image to its own folder and changing its file format
- Blending images to improve dynamic range

In this chapter, I intentionally present a simple workflow through Adobe Camera Raw without including all of its features because, first, you simply don't need all of the features, and second, some of the features are better done in Photoshop CS2 proper. For instance, it is better to control sharpening and noise reduction toward the end of the workflow (in Photoshop) than at the beginning, so I use the Detail tab (located in Adobe Camera Raw) infrequently. I don't use the Calibrate or Lens tabs (both in Adobe Camera Raw) either, because Calibrate is useful for studio work, for which you have constant light sources, and the Lens tab corrections are more complete in Photoshop proper, if they need to be done, by choosing the Filter | Distort | Lens Correction command.

This workflow also assumes one very important thing: that you have considered the luminosity of the original scene while taking the photograph, either from experience or through the Wratten 90 viewing filter (discussed in Chapter 3) or some similar device. Without understanding the importance of luminosity at the beginning of the process, you have no basis for understanding and adjusting color and black-and-white images at all.

For a more complete explanation of the features in Adobe Camera Raw, read Bruce Fraser's excellent book, *Real World Camera Raw with Adobe Photoshop CS2* (Peachpit Press, May 2005).

Transferring Images to the Computer

You can transfer photographs to a computer in a million different ways. I haven't tried all of them, but I've used the most popular methods and found the quickest and safest one uses a FireWire card reader. A USB 2 card reader is the next best option; it's not as fast as a FireWire connection, but on some Windows machines a USB 2 connection may be all you have. Very simply, this is what I do:

1. Take the memory card out of the camera.
2. Connect the FireWire or USB card reader to the computer and insert the memory card.
3. A memory card icon will show up on the desktop of a Mac, or a Removable Drive letter will appear inside the My Computer icon in Windows.
4. Create a new folder on the desktop (or any other place you choose) and name it.
5. Double-click the memory card icon or drive letter to open it.
6. Choose Edit | Select All to highlight all of the images on the memory card. Then choose Edit | Copy.
7. Open the new folder you just made and choose Edit | Paste to paste the images inside it.
8. Optional, but highly recommended: immediately back up this file of images to an external hard drive, CD, or DVD.

Basic Workflow for One Photograph Through Adobe Camera Raw

Adobe Camera Raw in Photoshop CS2 reads and processes 16-bit RAW files from every popular camera that shoots them. Camera Raw operates seamlessly with Adobe Bridge and imports the saved and manipulated files in TIFF, PSD, or PNG format directly into Photoshop. This ability to manipulate and optimize a 16-bit image before it gets into Photoshop is critical for outstanding results with digital workflows. The more optimized an image is before it hits Photoshop, the better it's going to be in the print.

> **Note**
>
> Depending on the kind of file and photograph you're working with, you can usually make all the following adjustments in less than 10 minutes.

1. Open Photoshop CS2 and click the Adobe Bridge icon just to the left of the palette well.

2. When Bridge opens, navigate to the folder that contains your RAW images. Double-click an image to open it in Adobe Camera Raw.

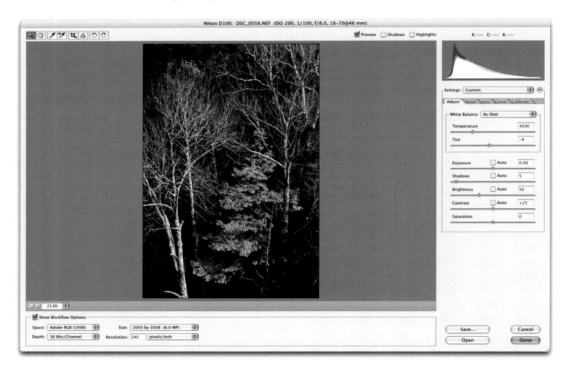

3. Along the bottom of the Adobe Camera Raw window, select the settings shown next. (The Size setting will vary according to the camera.)

4. For both color and black-and-white image input; adjust the Saturation slider all the way to the left to a setting of –100.

You are going to adjust only the luminosity first; you'll deal with the color adjustment in step 9. For reasons discussed in Chapter 3, you'll always adjust the luminosity separately from the hue and saturation components of color because it's difficult for the human visual perception mechanism to separate luminosity from hue and saturation. Remember when adjusting luminosity that you want to pay careful attention to good detail in the highlights and shadows and good midtone separation.

5. Adjust the white and black points by using the Exposure and Shadows sliders.

If you hold down the OPTION (Mac) or ALT (PC) key, you can see whether the image is clipped (areas in the picture where information or image pixels have been deleted) on either end. Watch the image itself and frequently look at the Histogram for clipping problems—they'll show up as vertical spikes on either end of the Histogram (see Figure 4-1).

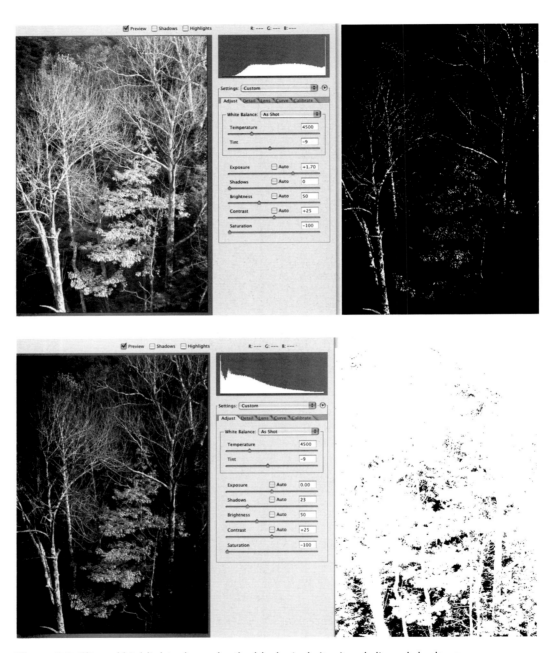

Figure 4-1: Clipped highlights shown by the black pixels (top) and clipped shadows shown by the white pixels (bottom)

6. Adjust the Brightness and Contrast sliders together to create a grayscale image that has good detail in the diffuse shadows and highlights and good middle gray value separation.

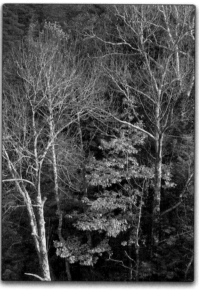

7. Click the Curve tab. Adjust the curve so that rough local adjustments are made to the image. (See the sidebar "Curves Primer" at the end of this chapter.)

8. Click the Adjust tab.

For a color image, move the Saturation slider to 0. Then adjust white balance (hue) by choosing an option from the White Balance drop-down menu and by adjusting the Temperature and Tint sliders.

And here is the final color image. For a black-and-white image similar to this one, leave the Saturation slider at –100.

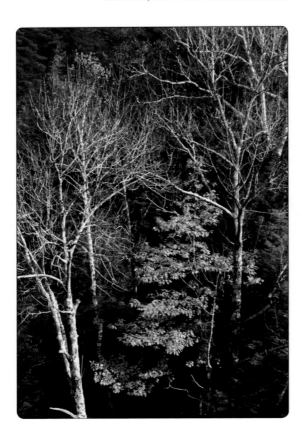 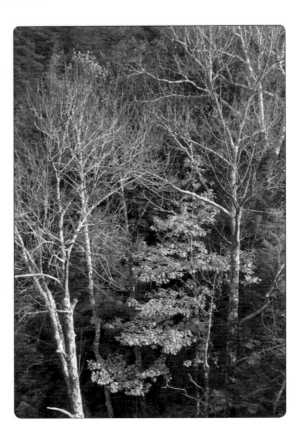

9. Choose the Crop tool from the Toolbox in the upper-left corner of the Camera Raw window. You have adjusted the major points of overall contrast and some rough local contrast, and you've corrected the white balance. The aesthetic controls you've adjusted to see the image fairly well are excellent at this point, so it is safe to crop. The Adobe Camera Raw Crop tool works just like it does in Photoshop: Click and drag from the upper-left corner, make a rough crop, and adjust the square handles in the middle of each side in and out to refine. This is called a *nondestructive* crop, which means that it won't affect the RAW file, but it will show up as cropped when you open it in Photoshop.

10. Click Save at the bottom right of the Camera Raw window. (The rest of the workflow is shown for a Macintosh computer, but a similar workflow can be accomplished in Windows.)

11. In the Save Options window, click Select Folder.

12. In the Select Destination Folder window, click Desktop from the list on the left and then click New Folder at the bottom.

13. In the New Folder window, name the folder and click Create.

14. The name of the folder will appear at the top of the Select Destination Folder window. Click Select at the bottom.

In the Format section of the Save Options window, choose a file format (usually either TIFF or PSD) and click Save. Wait for the Save message to disappear and click Done.

15. Copy the image inside the folder and open it in Photoshop CS2. On the Mac, simply click and drag the image while holding down the OPTION key. In Windows, right-click the image, choose Copy from the pop-up menu, right-click again, and choose Paste.

Basic Workflow for Two Photographs Through Adobe Camera Raw to Increase Dynamic Range

Since the late 1990s, great advances have altered how we think about the problem of dynamic range in photographs. The traditional method was to control the contrast of the black-and-white negative with exposure and development (Ansel Adams' famous Zone System) so that it contained the necessary detail for printing in the darkroom. Many photographers also used contrast-reducing masks for both black-and-white and color photography. In digital photography, we've had to reinvent how we control the dynamic range (contrast) in the image. The methods usually involve combining two registered images that have been taken using a tripod. Some of these involve masking while others use sophisticated software coding. I'll show two of these methods: one that uses Optipix software and one that uses two images on layers that employ a mask. (Chris Russ, an imaging scientist, and I invented the Optipix method, and the masking technique is from Katrin Eismann, noted Photoshop writer and educator.) The reasons for controlling dynamic range were discussed in Chapter 3.

For this procedure, you need to have bracketed three exposures with your camera mounted on a tripod: one at the correct exposure, a second at one stop overexposed, and a third at one stop underexposed.

Blending Exposures in Optipix

The workflow for this procedure is essentially the same as the basic workflow (steps 1–8) for one photograph discussed earlier in this chapter. The only real changes are that you are working with two images rather than one and not as much adjustment is typically used in Adobe Camera Raw. I'll provide illustrations only where the change is particular to blending the exposures in Optipix.

Note

If you have not done so previously, be sure to install Optipix before proceeding.

1. Open Photoshop CS2 and click the Adobe Bridge icon to the left of the palette well.

2. When Bridge opens, navigate to the folder that contains your RAW images.

3. Select the two images from the three-exposure bracket sequence that are the overexposed and underexposed frames: to select them, ⌘-click (Mac) or CTRL-click (Windows) on the overexposed and underexposed images in Bridge. Then press ⌘-O/CTRL-O (those are "ohs," not zeros) to open the images in Adobe Camera Raw.

4. Make sure the Auto checkboxes are unchecked by pressing ⌘-U/CTRL-U. You can make this permanent by going to the Settings drop-down menu (under the Histogram), resetting the Camera Raw defaults, unclicking Use Auto Adjustments (so that the Auto checkboxes are turned off), and clicking Save New Camera Raw Defaults. Note that this setting is specific for each digital camera you own.

5. In the upper-left corner of the Camera Raw window, click Select All.

6. Just under Select All, click Synchronize. In the Synchronize window, uncheck all the boxes except White Balance, and then click OK.

7. For a color image, adjust white balance (hue) by choosing an option from the White Balance drop-down menu and also adjusting the Temperature and Tint sliders.

For a black-and-white image, move the Saturation slider to –100.

8. At the bottom right of the Camera Raw window, click Save 2 Images. (The rest of the workflow is shown for a Macintosh computer, but a similar workflow can be accomplished in Windows.)

9. Save and copy the images by duplicating steps 10–15 from the preceding basic workflow for one photograph. Open both images in Photoshop.

10. Select one of the open images in Photoshop and choose Filter | Optipix | Setup 2nd Image. Select the other image and choose Filter | Optipix | Blend Exposures. The blended image will replace the second image.

11. Choose Image | Duplicate. Rename and save this image to the same folder containing the two originals that were blended.

In the blended copy, you should see good detail in both the shadows and highlights. It may appear a bit flat in contrast, but you can fix this later.

Depending on the size of the photograph, this procedure takes only a few minutes. (It takes many more words to explain than to show.)

> **Note**
>
> I have made no adjustments in Adobe Camera Raw before blending the two images except adjusting white balance for color and desaturation for black and white. This does not mean that you cannot use the other functions of Camera Raw; it's just that blending the two images together with the corrections may cause weird alignment problems later. I am especially suspicious of cropping and rotating the two images before blending, so it's not a good idea to perform either of these procedures until after the images are combined and saved. I suggest waiting until after you read Chapter 8, where we'll be adjusting overall contrast and color, so you can see the image fairly well optimized. If, however, the image was viewed in a different aspect ratio than the camera format (say a square or panorama), I would not hesitate to crop at least those parts of the image that are not essential to the visualized image. What I'm saying in general here is that if you are sure about the composition, crop; if you aren't sure, wait.

Many people use one RAW image, adjust the file for highlights, save, and then take the same image, adjust the file for shadows, and save. This provides one image for the highlights and one for the shadows that can then be blended. I've found that this procedure does not work as well as the two separate blended exposures, but you might need to try it to convince yourself. However, if you have only one image, reprocessing for the highlights and shadows may be the only way to save the dynamic range of the photo.

Combining Two Images Using the "Claw"

I picked up this "claw" technique (named for the position your fingers have to be in to make the keyboard shortcut for luminosity) from Katrin Eismann. It's an easy technique that is very useful for combining two images if you don't own Optipix (though Optipix is more accurate and more powerful in its conversion). Steps 1–8 are nearly identical to those for using blended exposures in Optipix, as described earlier in the chapter.

1. Open Photoshop CS2 and click the Adobe Bridge icon to the left of the palette well.

2. When Bridge opens, navigate to the folder that contains your RAW images.

3. Select the two images from the three-exposure bracket sequence that are the overexposed and underexposed frames: ⌘-click (Mac) or CTRL-click (Windows) the overexposed and underexpose images in Bridge. Then press ⌘-O/CTRL-O to open them in Adobe Camera Raw.

4. Make sure the Auto checkboxes are unchecked by pressing ⌘-U/CTRL-U. You can make this permanent by going to the Settings drop-down menu (under the Histogram), resetting the Camera Raw defaults, unclicking Use Auto Adjustments (so that the Auto checkboxes are turned off), and clicking Save New Camera Raw Defaults.

5. In the upper-left corner of the Camera Raw window, click Select All.

6. Just under Select All, click Synchronize. Uncheck all the boxes except White Balance and click OK.

7. For a color image, adjust white balance (hue) by choosing an option from the White Balance drop-down menu and adjusting the Temperature and Tint sliders.

 For a black-and-white image, move the Saturation slider to −100.

8. At the bottom-right corner of the Camera Raw window, click Save 2 Images. (The rest of the workflow is shown for a Macintosh computer, but a similar workflow can be accomplished in Windows.)

9. Save and copy the images by duplicating steps 10–15 from the basic workflow for one photograph, earlier in this chapter. Open both images in Photoshop.

10. With both images open in Photoshop, select the Move tool in the Photoshop Toolbox, select the underexposed image, hold down the SHIFT key, and click and drag the underexposed image onto the overexposed image. By holding down the SHIFT key, the images should be precisely aligned.

11. Immediately choose Image | Duplicate. Rename and save this image to the same folder that contains the two originals that were blended.

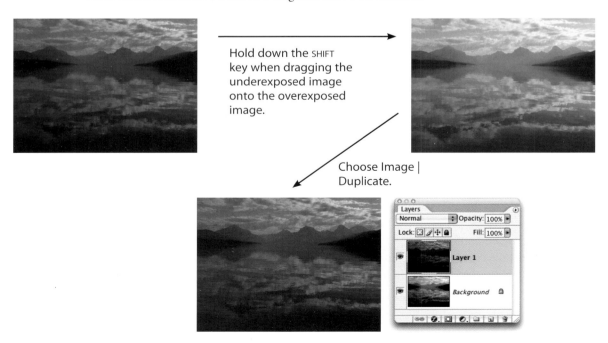

Hold down the SHIFT key when dragging the underexposed image onto the overexposed image.

Choose Image | Duplicate.

12. Select the Background layer (overexposed image) and press ⌘-OPTION-1/ CTRL-ALT-1. Turn off the eye for the top layer so the bottom, overexposed layer is visible. You will see the "marching ants," indicating a selection of the luminosity.

Note

On a Mac running OS 10.4, this shortcut may conflict with shortcuts already established for the operating system. If this problem occurs do the following:

1. Open System Preferences.
2. Click Keyboard & Mouse.
3. Select Keyboard Shortcuts.
4. Scroll down to the Keyboard Navigation section.
5. Turn off any shortcuts by pressing ⌘-OPTION-~(tilde).
6. Close System Preferences.

13. Select the top layer (the underexposed image) and make a layer mask by clicking the New Layer Mask icon at the bottom of the Layers palette. You will see the two images seamlessly blend together in the top (underexposed) layer.

New Layer Mask

14. Flatten the image and save it in the same folder with the two originals.

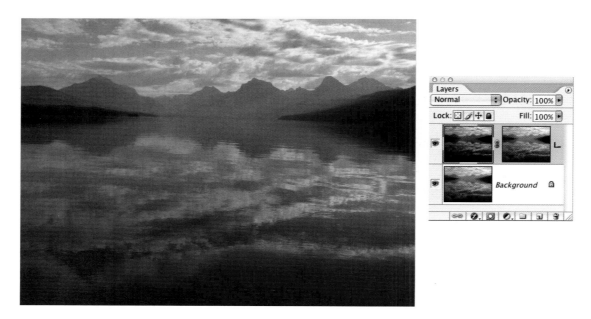

Blending More Than Two Images Using Optipix

Some contrast situations involve such a broad range of brightness that blending two images together won't solve the problem of controlling the dynamic range. Photoshop CS2 has a new feature that was invented to handle just this type of difficulty—HDR conversion—but, unfortunately, its workflow is confusing and includes many steps that are either not simple to understand or are problematic in their results.

I worked on the HDR part of the alpha and beta versions of Photoshop CS2 and am convinced that it can be greatly improved. Until that time, Optipix has a simple-to-operate feature called Show Average that allows you to combine up to 30,000 images to get a broader dynamic range. I usually bracket in a series of five, seven, or nine images, each one stop apart (taken on a tripod).

> **Note**
>
> If you want to try Photoshop CS2 HDR, see Ben Wilmore's book, *Photoshop CS2: Up to Speed* (Peachpit Press, June 2005), and the section on High Dynamic Range Imaging.

1. Select the images (five, seven, or nine exposures) in Adobe Bridge—SHIFT-click to select all of them. Then press ⌘-O/CTRL-O to open them in Adobe Camera Raw.

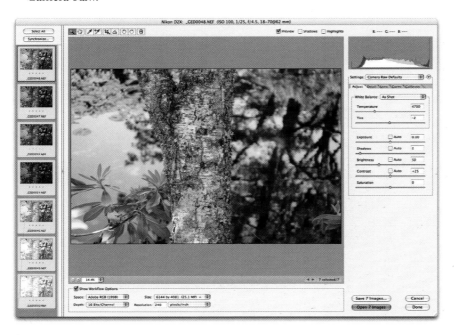

2. Make sure the Auto checkboxes are unchecked by pressing ⌘-U/CTRL-U. You can make this permanent by going to the Settings drop-down box (under the Histogram), resetting the Camera Raw defaults, unclicking Use Auto Adjustments (so that the Auto checkboxes are turned off), and clicking Save New Camera Raw Defaults.

3. In the upper-left corner of the Camera Raw window, click Select All.

4. Just under Select All, click Synchronize. Uncheck all the boxes except White Balance and click OK.

5. For a color image, adjust white balance (hue) by choosing an option from the White Balance drop-down menu and also adjusting the Temperature and Tint sliders.

For a black-and-white image, move the Saturation slider to –100.

6. At the bottom right of the Camera Raw window, click Save *(5, 7, or 9)* Images.

7. Save and copy the images by duplicating steps 10–15 from the basic workflow for one photograph, earlier in this chapter. Then open all the images in Photoshop.

8. Choose Filter | Optipix | Clear Buffer to clear the buffer (holding pen) of any images.

9. Select the first image (it doesn't matter which one), and choose Filter | Optipix | Add To Buffer. Continue selecting each image and adding it to the buffer. But instead of choosing Filter | Optipix | Add To Buffer each time, use the keyboard shortcut: ⌘-F/CTRL-F.

10. After you've put all the images into the buffer, for the last image selected, choose Filter | Optipix | Show Average, and the blended result of all the images will appear.

11. Immediately choose Image | Duplicate. Rename and save this image to the same folder used for the originals that were combined. The combined image is shown here.

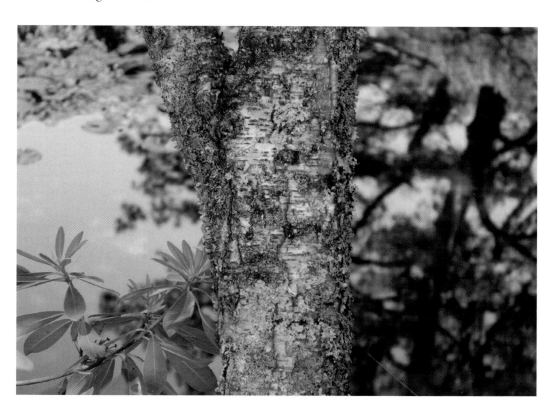

Curves Primer

Curves in Photoshop and Camera Raw can appear daunting to many, but knowing just a few simple concepts about curves can help make quick work of its seeming complexities.

Photoshop CS2 Curves window

When you first open Curves, you'll see a diagonal line running across a grid from the lower left to the upper right. In the Adobe Camera Raw Curve tab, the lower point of the line represents 100% black and the upper point of the line represents 100% white. In the Photoshop CS2 Curves window, if the lower left point of the line is not represented by black, as shown by the grayscale just beneath the grid, click the double arrow in the middle of the grayscale to change it. The black on the grayscale should be on the left and white should be on the right.

Note that this diagonal line represents your image before you make any corrections. In Camera Raw, this line stays grayed out and in its original position as you adjust the image, and this makes it easier to see what's happening to the brightness and contrast. In Photoshop, after you adjust curves, no original grayed line remains, so you have to imagine it. Someday, the Adobe engineers will put that original grayed diagonal line in the Photoshop Curves window (as they did in Camera Raw) because, as you'll see, it comes in handy.

Here is an image opened in Adobe Camera Raw, with the original curve.

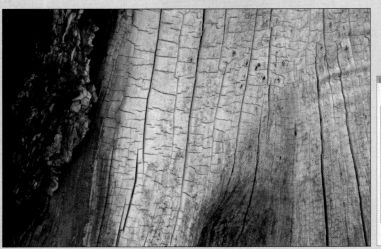

If you increase the steepness of the curve, the image increases in contrast. If you decrease the steepness of the curve, the image decreases in contrast as shown by the following two images.

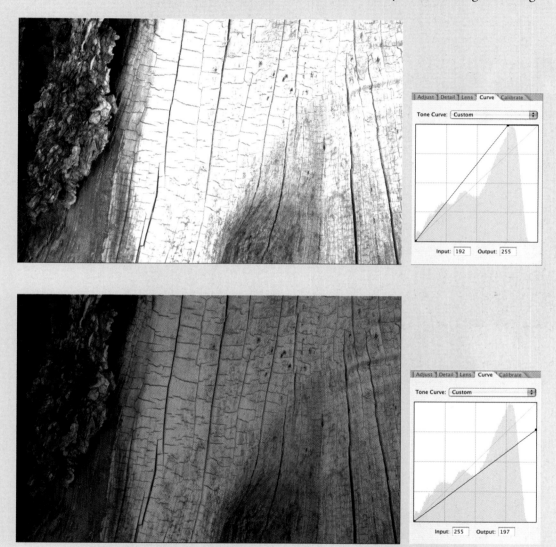

(continued)

Curves Primer *(continued)*

If the top of the curve is convex, or curving upward, you increase brightness. If the top of the curve is concave, or curving downward, you decrease brightness.

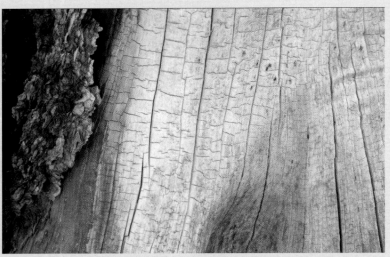

That's basically all you need to know about how curves work. Let's see how this pans out. The following images show the original curve and the corrected curve.

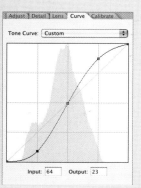

Notice in the corrected curve that the shadows and the highlights are flatter than in the original. Because the curve here is less steep than the original one, the image is flatter. Now look at the midtone section of the curve. Because it is steeper than the original, the image has more contrast.

Input and Copy: Workflow for JPEG Files

As mentioned in Chapter 4, you will want to use *either* the workflow in this chapter *or* the workflow in Chapter 4, depending on the nature of your input. If you are starting with JPEG files, you'll use the workflow in this chapter. If you are starting with RAW files, you can skip this chapter and read Chapter 4 instead (if you haven't already). For either type of input, your next step is to proceed with the workflow described in Chapter 6.

In this chapter, you will learn how to do the following:

- Transfer an image from the camera to the computer safely.
- Use Photoshop CS2 to make preliminary adjustments to JPEG files, change their file format, and prepare them for optimizing in Photoshop.
- Copy the image to its own folder.
- Blend images to improve dynamic range.

If you've read Chapter 4, this chapter on inputting JPEG files might seem similar, but you should make note of some differences. For one thing, because you have no real way of controlling the JPEG image before you get it into Photoshop, as you do with RAW files, you must perform those adjustments further down the line in the workflow. In future chapters, the RAW and JPEG workflows will for all intents and purposes be nearly identical. The essential difference between this chapter and Chapter 4 is the basic preparation of JPEG images in Photoshop (rather than in Adobe Camera Raw), the way you save the images, and when you should crop images. The three methods of increasing the dynamic range are the same, and you can refer to the illustrations in Chapter 4 for reference if you need to.

Transferring Images to the Computer

You can transfer photographs to a computer in a million different ways. I haven't tried all of them, but I've used the most popular methods and found the quickest and safest one uses a FireWire card reader. A USB 2 card reader is the next best option; it's not as fast as a FireWire connection, but on some Windows machines a USB 2 connection may be all you have. Very simply, this is what I do:

1. Take the memory card out of the camera.

2. Connect the FireWire (or USB) card reader to your computer and insert the memory card.

3. A memory card icon will appear on the desktop of a Mac, or a Removable Drive letter will appear inside the My Computer icon in Windows.

4. Create a new folder on the desktop (or any other place you choose) and name it.

5. Double-click the memory card icon or drive letter to open it.

6. Choose Edit | Select All to highlight all of the images on the memory card. Then choose Edit | Copy.

7. Open the new folder you just made and choose Edit | Paste to paste the images inside it.

8. Optional, but highly recommended: immediately back up this file of images to an external hard drive, CD, or DVD.

Basic Preparation of JPEG Images

Preparing JPEG images is simple if you stick to some important workflow guidelines. One of the most important of these is immediately changing the JPEG file to a TIFF to avoid file compression and reduce digital artifacts.

1. From the Adobe Bridge program, open a JPEG image in Photoshop by double-clicking it.

2. Choose Image | Mode | 16 Bits/Channel. Changing the JPEG to 16 bits per channel acts as a protection against image destruction in Photoshop.

3. Immediately choose File | Save As. (The rest of the workflow is shown for a Macintosh computer, but a similar workflow can be accomplished in Windows.)

4. In the Save As window, scroll through the Format drop-down menu and choose TIFF. Immediately saving a JPEG file as a TIFF keeps it from compressing and destroying the image. Click Desktop in the list at the left of the window. Click New Folder at the bottom left.

5. Name the folder and click Create.

6. In the Save As drop-down menu at the top of the window, type in a new name for the file.

7. Click Save.

8. Copy the image inside the folder and open it in Photoshop CS2. On a Mac, simply click and drag the image while holding down the OPTION key. In Windows, right-click the image, choose Copy from the pop-up menu, right-click again, and choose Paste.

> **Note**
>
> It's not a good idea to crop JPEG or TIFF images before they are optimized and adjusted for color balance (which you'll learn to do in Chapter 8), because you do not have the special pre-control over contrast and white balance that you had in Adobe Camera Raw. You need to see the image fairly well along in its development before committing to an aesthetic decision like cropping. If, however, the image was viewed in a different aspect ratio than the camera format (say, a square or panorama), then you should not hesitate to crop at least those parts of the image that are not essential to the visualized image. In general, if you are sure about the composition, go ahead and crop; if you aren't sure, better to wait.

Basic Workflow for Two JPEG Images to Increase Dynamic Range

Since the late 1990s, great advances have altered how we think about the problem of dynamic range in photographs. The traditional method was to control the contrast of the black-and-white negative with exposure and development (Ansel Adams' famous Zone System) so that it contained the necessary detail for printing in the darkroom. Many photographers also used contrast-reducing masks for both black-and-white and color photography. In digital photography, we've had to reinvent how we control the dynamic range (contrast) in the image. The methods usually involve combining two registered images that have been taken using a tripod. Some of these involve masking while others use sophisticated software coding. I'll show two of these methods: one that uses Optipix software and one that uses two images on layers that employ a mask. (Chris Russ, an imaging scientist, and I invented the Optipix method, and the masking technique is from Katrin Eismann, noted Photoshop writer and educator.) The reasons for controlling dynamic range were discussed in Chapter 3.

For this procedure, you need to have bracketed three exposures with your camera mounted on a tripod: one at the correct exposure, a second at one stop overexposed, and a third at one stop underexposed.

Blending Exposures in Optipix

If you have not done so previously, be sure to install Optipix before proceeding.

1. Open Photoshop CS2 and click the Adobe Bridge icon to the left of the palette well.

2. When Bridge opens, navigate to the folder that contains your JPEG images.

3. Select the two images from the three-exposure bracket sequence of overexposed and underexposed frames. Do this by ⌘-clicking (Mac) or CTRL-clicking (Windows) on the overexposed and underexposed images in Bridge. Then press ⌘-o/CTRL-o (those are "ohs," not zeros), and they will both open in Photoshop.

4. Prepare each image as you did in steps 2–8 of "Basic Preparation of JPEG Images," earlier in this chapter.

5. Select one image to open in Photoshop and choose Filter | Optipix | Setup 2nd Image.

6. Select the other image and choose Filter | Optipix | Blend Exposures. The blended image will replace the second image.

7. Immediately choose Image | Duplicate. Rename and save this image to the same folder as the two originals that were blended.

If you look at the blended image in Levels, you can see that no part of the image (at least in most photographs) is clipped, and you have good detail in both the shadows and highlights. (*Clipped* areas are where information or image pixels have been deleted in the picture.)

Depending on the size of the photograph, this procedure takes only a couple of minutes. (It takes many more words to explain than to show.)

> **Note**
>
> I made no color or contrast adjustments in Photoshop before blending the two images. This does not mean that you cannot use the other functions of Photoshop—it's just that blending the two images together with the corrections may cause weird alignment problems later. I am especially suspicious of cropping and rotating two images before blending, so it's not a good idea to perform either of these procedures until after the images are combined and saved. I suggest waiting until you've read Chapter 8, where you'll be adjusting overall contrast and color so you can see the image fairly well optimized.

Combining Two Images Using the "Claw"

I picked up the "claw" technique (named for the position your fingers have to be in to make the keyboard shortcut for Luminosity) from Katrin Eismann. It's an easy technique that is very useful for combining two images if you don't own Optipix (though Optipix is more accurate and more powerful in its conversion).

1. Open Photoshop CS2 and click the Adobe Bridge icon to the left of the palette well.

2. When Bridge opens, navigate to the folder that contains your JPEG images.

3. Select the two images from the three-exposure bracket sequence that are the overexposed and underexposed frames: ⌘-click/CTRL-click the overexposed and underexposed images in Bridge, and then press ⌘-O/CTRL-O ("ohs," not zeros) and they will both open in Photoshop.

4. Prepare each image as you did earlier in steps 2–8 of "Basic Preparation of JPEG Images."

5. With both images open in Photoshop, select the Move tool in the Photoshop Toolbox. Then select the underexposed image, hold down the SHIFT key, and click and drag the underexposed image onto the overexposed image. (Holding down the SHIFT key lets you precisely align the images.)

6. Immediately choose Image | Duplicate. Rename and save this image to the same folder as the two originals that were blended.

7. Select the Background layer (overexposed image) and press ⌘-OPTION-1/ CTRL-ALT-1. Turn off the eye for the top layer so the bottom, overexposed layer is visible. You will see the "marching ants," indicating a selection of the luminosity.

8. Select the top layer (the underexposed image) and create a layer mask by clicking the New Layer Mask icon at the bottom of the Layers palette. You will see the two images then seamlessly blend together in the top (underexposed) layer.

9. Flatten the image and save it in the same folder as the two originals.

> **Note**
>
> On a Mac running OS 10.4, some keyboard shortcuts may conflict with shortcuts already established for the operating system. If this problem occurs, do the following:
>
> 1. Open System Preferences.
> 2. Click Keyboard & Mouse.
> 3. Select Keyboard Shortcuts.
> 4. Scroll down to the Keyboard Navigation section.
> 5. Turn off any shortcuts using the ⌘-OPTION-~(tilde) keys.
> 6. Close System Preferences.

Blending More Than Two Images Using Optipix

Some contrast situations involve such a broad range of brightness that blending two images together won't solve the problem of controlling the dynamic range. Photoshop CS2 has a new feature that was invented to handle just this type of difficulty—HDR conversion—but, unfortunately, its workflow is confusing and includes many steps that are either not simple to understand or are problematic in their results.

I worked on the HDR part of the alpha and beta versions of Photoshop CS2 and am convinced that it can be greatly improved. Until

that time, Optipix has a simple-to-operate feature called Show Average that allows you to combine up to 30,000 images to get a broader dynamic range. I usually bracket in a series of five, seven, or nine images, each one stop apart (taken on a tripod).

Note

If you want to try Photoshop CS2 HDR, see Ben Wilmore's book, *Photoshop CS2: Up to Speed* (Peachpit Press, June 2005), and the section on High Dynamic Range Imaging.

1. Open the images in Photoshop (five, seven, or nine exposures) by following steps 1–5 in "Combining Two Images Using the 'Claw'" earlier in this chapter.
2. Choose Filter | Optipix | Clear Buffer to clear the buffer (holding area) of any images.
3. Select the first image (it doesn't matter which one), and choose Filter | Optipix | Add To Buffer. Continue selecting each image and adding it to the buffer—but instead of choosing Filter | Optipix | Add To Buffer each time, use the keyboard shortcut ⌘-F/CTRL-F instead.
4. Once you've added all the images to the Buffer, for the last image selected, choose Filter | Optipix | Show Average, and the blended result of all the images will appear.
5. Immediately choose Image | Duplicate. Rename and save this image to the same folder as the originals that were blended.

Optimize Contrast and Detail, and Balance the Image

Optimizing an image before you start adjusting color and local details is a very important yet often overlooked step in creating an excellent digital fine print. In this step of the workflow, we're considering two factors. The first is the fact that a RAW or JPEG file is processed through the camera's analog to digital converter and "corrupted," causing the image either to be slightly out-of-focus or, in a JPEG file, to exhibit artifacts from compression, both of which obscure detail. Most photographers would agree that this condition is not good. This is also the crux of RAW conversion and a topic that generates lots of controversy. Each digital camera manufacturer uses its own algorithm—a precise rule, or set of rules—specifying how to solve the problem of converting RAW files. At any rate, you must face the chore of correcting the out-of-focus details that result from these conversions. This process is called *optimization*, which simply means that you try to make the best overall image possible before you make the small local adjustments that refine and render it an excellent and masterful print. The second factor is visual balance of the image; its overall balance of brightness. The top of the picture may seem too light or one of the sides seem to dark. Balancing corrects these and other overall brightness inequalities.

In this chapter you will learn the following:

- Techniques to return original image detail that was lost in pre-Photoshop processing
- Contrast adjustment to reclaim lost highlight and shadow detail
- Methods for balancing an image tonally with gradients

Here's what you will use:

- Optipix software
- Photoshop CS2
- Gradient tool
- Layers palette
- nik Sharpener Pro 2.0 (or later) software (optional)

You can optimize an image in many ways, but the three methods I show you in this chapter work the best for me. One of my methods uses Optipix; two other methods use nik Sharpener Pro and Photoshop CS2. I sometimes use all three to see which works the best on a particular image.

Optipix Refocus and the Photoshop CS2 Smart Sharpen filter with Lens Blur all use similar algorithms. The nik Sharpener Pro 2.0 Raw Presharpening filter is slightly different but works to serve the same purpose. Though they are proprietary applications, they share a common origin: The software is similar to the software used to repair the Hubble Telescope's initial focus problem. It's called a *deconvolution algorithm*. Deconvolution starts with the problem in question (in our case, an out-of-focus image) and works backward to arrive at what the image actually should look like. It then reconfigures the image to look like it should have in the first place. In simpler words, light in the image is smeared, and the deconvolution algorithm puts the smeared mess back into a shape.

So why do you need to know this? Because even though the tools we'll use have the word *sharpen* in them, this procedure is different from what you might traditionally expect: it's not like Unsharp Mask in Photoshop. Unsharp Mask works largely on the *edges* of images, but a deconvolution algorithm works on *details*. Even though the procedure you'll follow in this chapter is called *sharpening* and even though it *looks* like sharpening, it is really about *enhancing detail*.

Note

The steps outlined in all three optimization processes can also be made into Actions, which I strongly recommend. (An Action for optimizing is included on the Optipix CD.) Actions are discussed in Chapter 7.

Once you refocus the image, you'll want to sharpen the details. Optipix's Detail Sharpener is a modification of Photoshop's interactive high pass sharpening method that ignores edges and favors detail. You want to sharpen details *after* you refocus/sharpen the entire image. nik Sharpener Pro and Photoshop Smart Sharpen seem to combine both the deconvolution algorithm with some detail sharpening, but the detail sharpening does not seem to be controllable.

Balancing is a process that uses *gradients* in Photoshop to even out large irregular areas of brightness that occur mostly at the edges of an image. I've found that balancing gives me a better overall sense of where to adjust local contrast and brightness. As with adjusting overall sharpness, balancing occurs before you adjust local areas of detail.

Optimizing the Image with Optipix Refocus

The following images show the original (top) and a segment of it enlarged to 100% (Actual Pixels) to show you the softness caused by the raw converter process. Optipix Refocus corrects this problem.

1. In Photoshop, open the Layers palette. Duplicate (copy) the Background layer by dragging the layer to the New Layer icon at the bottom of the Layers palette.

2. Choose Filter | Optipix | Refocus and accept the default settings shown here. Then click OK.

New Layer

3. On the Background copy, set the Mode to Luminosity and the Opacity to 75%.

4. Flatten the image by clicking the arrow at the upper-right corner of the Layers palette and choosing Flatten Image.

5. Choose Image | Adjustments | Levels, and set the Output sliders in the Levels window to 30 and 230. Notice I said *Output* sliders, not Input sliders. The Output sliders are below the Input sliders. The image now looks flat. What you have just done is opened the highlights and shadows so that you can reclaim any lost detail in the image. (This will be done in the next step.) Click OK.

6. Choose Filter | Optipix | Detail Sharpener and use the settings for Neighborhood Radius, Threshold Limit, and Detail Emphasis that are shown here. You can adjust these sliders later if the effect is either too little or too great. (See the Optipix User's Guide for more information about these settings.) Click OK.

7. Choose Filter | Optipix | Auto Contrast, and set the 50% Point field to Linear, with a Tail Clip setting of of 0.00100 percent. Click OK.

8. This step is optional and used only if the contrast is too high: In Photoshop, choose Edit | Fade Auto Contrast. In the Fade window, adjust the Opacity slider to the left. Click OK.

9. Save the image (choose File | Save). The following shows the original image (left) and the final image (right).

Optimizing the Image with nik Sharpener Pro Raw Presharpening

For those of you who have nik Sharpener Pro, this is similar to the Optipix routine that accomplishes virtually the same optimize and detail procedure.

1. In Photoshop, open the Layers palette. Duplicate (copy) the Background layer by dragging the layer to the New Layer icon at the bottom of the Layers palette. (This is identical to step 1 in the previous section, "Optimizing the Image with Optipix Refocus.")

2. Choose Image | Adjustments | Levels and set the Output sliders in the Levels window to 30 and 230. Notice I said *Output* sliders, not Input sliders. The Output sliders are below the Input sliders. The image now looks flat. You have opened the highlights and shadows so that you can reclaim any lost image detail, which you will do in the next step. (This is identical to step 5 in "Optimizing the Image with Optipix Refocus.") Click OK.

3. Choose Filter | nik Sharpener Pro 2.0 | Raw Presharpening. Here, you move the Strength slider to adjust image sharpening as appropriate for the image. When adjusting the slider, 0 percent indicates low sharpening, and 50 percent is a very high setting. Try starting at the default setting (halfway). Click OK.

4. Choose Image | Adjustments | Auto Contrast.

5. Choose Edit | Fade Auto Contrast, and adjust the Opacity slider (default is 100%) to the left to reduce the effect of the sharpening. 0% Opacity is the same as the original sharpen.

6. Flatten the image by clicking the arrow at the upper-right corner of the Layers palette and choosing Flatten Image. Then choose File | Save.

Optimizing the Image with Photoshop CS2 Smart Sharpen

For those of you who have neither Optipix nor nik Sharpener Pro, the Smart Sharpen filter in Photoshop CS2 offers a third way to optimize the image.

1. In Photoshop, open the Layers palette. Duplicate (copy) the Background layer by dragging the layer to the New Layer icon at the bottom of the Layers palette. (This is identical to step 1 in both of the previous procedures.)

2. Choose Image | Adjustments | Levels and set the Output sliders in the Levels window to 30 and 230. Notice I said *Output* sliders, not Input sliders. The Output sliders are below the Input sliders. The image now looks flat. You have opened the highlights and shadows so that you can reclaim any lost image detail in the next step. (This is identical to step 5 of the first procedure, and step 2 of the second procedure.) Click OK.

3. Choose Filter | Sharpen | Smart Sharpen. In the Smart Sharpen window, choose the Basic radio button. In the Settings drop-down menu, choose Default. Set the Amount to 300%, Radius to 0.8 pixels, Remove to Lens Blur, then click OK.

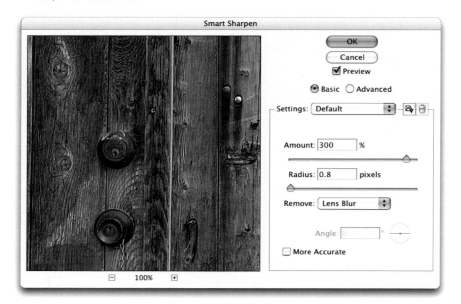

4. Choose Image | Adjustments | Auto Contrast.

5. Choose Edit | Fade Auto Contrast, and adjust the Opacity slider (default is 100%) to the left to reduce the effect of the sharpening. 0% Opacity is the same as the original sharpen.

6. Flatten the image by clicking the arrow at the upper-right corner of the Layers palette and choosing Flatten Image. Then choose File | Save.

Balancing

Adjusting balance means correcting broad areas in an image that are either too bright or too dark. These adjustments are "in between" overall brightness adjustments and local brightness problems. The differences among overall, broad, and local adjustments are that *overall* adjustments work on the picture as a whole, *broad* adjustments work on specific areas, and *local* controls adjust small objects or areas within those areas in the image. Balancing is a broad area adjustment. Let's analyze an image and see how balancing works.

This image of a doorway in Santa Fe seems like an easy fix at first glance. It's been through the optimization process but still needs three adjustments:

- The left third of the picture is too light and needs to be darkened.
- The right two-thirds of the picture is too dark and needs to be lightened.
- Both sides need slightly more contrast. It's a subtle but important setting. If you are having trouble seeing this, squint at the picture to dissolve the details so that you can better see the overall pattern of brightness.

My favorite way to fix this kind of problem is by using Photoshop's Gradient tool. If I apply two gradients, one on the left third and one on the right two-thirds, to match the offending brightness in the image, and then fade those gradients, I can achieve brightness balance easily. To increase the contrast slightly, I'll add the Soft Light mode to each gradient.

Gradient tool

But before brightness problems can be fixed, you have to be able to see them. That's the trick. Balancing the brightness in a photograph is a matter of personal visual perception, taste, and "gut sense." It has little to do with technique. Accomplished photographers acquire this skill only after much practice.

After you spot a problem, you can use Photoshop to fix it. Following is a moderately complicated use of gradients to balance the image tonally, and hopefully you can see all the possibilities in this powerful technique. Not all images need to be balanced in this manner, but when they need it, this is the quickest way to do it:

1. In Photoshop, open the Layers palette. Duplicate the Background layer, as you did earlier in the chapter.
2. In the Toolbox, set the Foreground and Background colors to their defaults by clicking the smaller icon, as indicated in this illustration, or by pressing D. This will create a black foreground color and a white background color.

Set Foreground/
Background colors

3. Click the Gradient tool in the Toolbox.

4. In the Photoshop Options bar, click the small arrow to the right of the gradient sample, and choose the Foreground to Transparent gradient preset:

Linear Gradient

Foreground to Transparent

Make sure the Linear Gradient style is selected, Mode is set to Normal, and the Opacity is set to 100%. The Reverse checkbox should be unchecked, but Dither and Transparency should be checked.

5. Apply the dark gradient to the leftmost third of the image by clicking where you want the gradient to begin and drag twice as far beyond the area you want to correct. The gradient will appear, but it will probably look too dark, as shown in this image.

6. Choose Edit | Fade Gradient, set the Mode to Soft Light, and adjust the Opacity slider until the area to which you applied the gradient looks good, as shown in the image at right.

7. Reverse the Foreground and Background colors by clicking the curved arrow in the Foreground/Background Color icon (or press x). Now the Foreground is white and the Background is black.

8. Repeat steps 2 to 6, except in this case you'll be lightening the right two-thirds of the image.

9. Flatten the image by clicking the arrow at the upper-right corner of the Layers palette and choosing Flatten Image. Then choose File | Save.

The original image is shown on the left, and the final balance adjustment is shown on the right.

Creating the Digital Fine Print Layer Workflow

So far we've transferred the image to the computer, saved it to a folder, and run it through either a RAW or JPEG/TIFF single-layer (the Background layer) optimization routine that restores the focus of the original image. If you've been using RAW files, most of the overall work in brightness, contrast, and color balancing (white balance) is done. If you've been using JPEG or TIFF files, you need to perform a little more overall (otherwise called "global") correction.

But first, you'll need to set up the digital fine print *layer* workflow. This is a set of four layers that you will use to perform the adjustment of four of the six qualities of the digital fine print as described in Chapter 1: contrast (overall and local), brightness, color, and overall defects. This layer-based workflow is not only good for adjusting contrast, brightness, and color balance for JPEG and TIFF files, it is also good for viewing converted RAW files for overall contrast, brightness, and color (white) balance. Most importantly, it allows you perform the many *local* contrast, brightness, and color adjustments on a layer, and complete your corrections with a cleanup layer that allows you to eliminate defects.

Although it may seem a repetition of Chapter 6 to be working with overall contrast and color again, the layer on which these are made is also the one needed to apply the proof setup, which is necessary for viewing the image as it will be printed. At any rate, I find it's always a good thing to keep monitoring contrast and brightness throughout the editing process— *evaluate continually*—as this gives a second chance to see any problems that might arise. You'll see.

Figure 7-1 shows you how this layered workflow relates to the workflow for the overall workshop, as was shown in Chapter 1 (Figure 1-17).

Here's what you will do in this chapter:

- Create the digital fine print layer workflow manually
- Create the digital fine print layer workflow as a Photoshop Action

You will use the following Photoshop palettes:

- Layers
- Actions

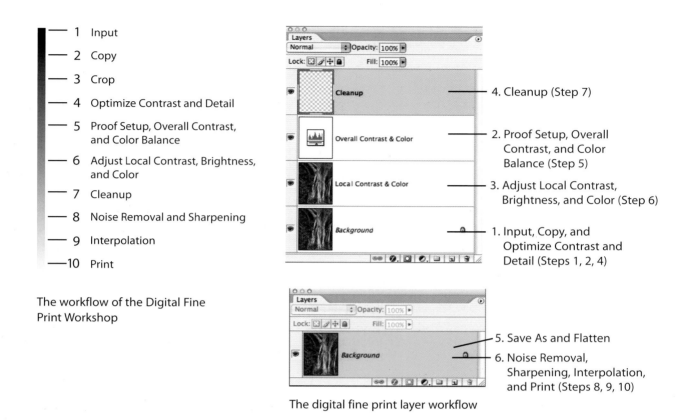

1 Input
2 Copy
3 Crop
4 Optimize Contrast and Detail
5 Proof Setup, Overall Contrast, and Color Balance
6 Adjust Local Contrast, Brightness, and Color
7 Cleanup
8 Noise Removal and Sharpening
9 Interpolation
10 Print

The workflow of the Digital Fine Print Workshop

4. Cleanup (Step 7)

2. Proof Setup, Overall Contrast, and Color Balance (Step 5)

3. Adjust Local Contrast, Brightness, and Color (Step 6)

1. Input, Copy, and Optimize Contrast and Detail (Steps 1, 2, 4)

5. Save As and Flatten

6. Noise Removal, Sharpening, Interpolation, and Print (Steps 8, 9, 10)

The digital fine print layer workflow

Figure 7-1: The digital fine print layer workflow as related to the overall workshop workflow

Creating the Digital Fine Print Layer Workflow Manually

After you have made a copy of the image, placed it in its own folder, and optimized contrast and detail, you can make and apply the digital fine print layer workflow.

1. Open Photoshop, and then open the Layers palette.

2. Open a copy of your image. In the Layers palette you should see only a single layer named Background.

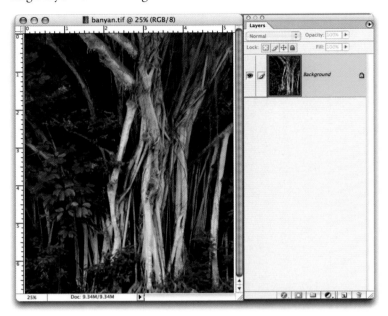

3. Create a copy of the Background layer by clicking and dragging the layer to the New Layer icon at the bottom of the Layers palette. Rename it Local Contrast & Color.

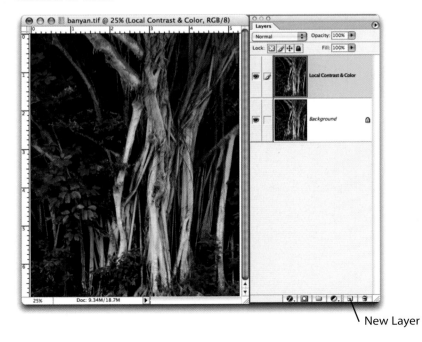

New Layer

Tip

To rename a layer, double-click it and type the name you want.

4. Create a Levels adjustment layer by clicking the half-moon icon at the
bottom of the Layers palette and choosing Levels. The Levels window
opens. Click OK and then discard the Layer Mask by dragging it to the
Trash Can icon at the bottom of the Layers palette. Rename the layer
Overall Contrast & Color.

Layer Mask

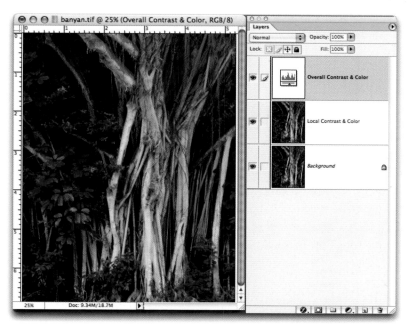

5. Create a regular layer by clicking the New Layer icon at the bottom of the Layers palette and name the new layer Cleanup.

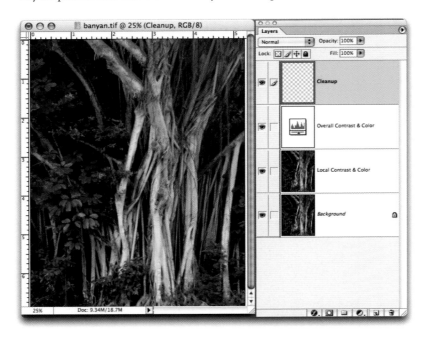

Creating and Applying the Digital Fine Print Layer Workflow Action

Using Actions in Photoshop is a good way to automate routines that you find yourself repeating often. An *Action* is a single Photoshop command, or *script*, that combines one or many procedures, filters, tools, and other features to make your use of Photoshop easier and more efficient. The following steps show you how to set up the digital fine print layer workflow as an Action. Although this is a specific Action setup, the general procedure can be used to make any Photoshop Action.

Note

For more information on Actions, see Photoshop Help (choose Help | Photoshop Help | Automating Tasks).

1. Open a photograph (16-bit RGB).

2. Open the Actions palette either from the palette well or by choosing Window | Actions.

3. Every Action lives in a set. To create an Action set, click the Create New Set icon at the bottom of the Actions palette. (If you don't create a set, Photoshop creates one for you. See Photoshop Help.)

Create New Set

4. In the New Set dialog box, enter **Digital Fine Print** for the Name and click OK. The new set name will appear in the Actions palette.

5. Create a new Action by clicking the Create New Action icon at the bottom of the Actions palette. In the New Action dialog box, enter **Digital Fine Print Workflow** for Name and click Record.

6. Going back to the previous procedure, "Creating the Digital Fine Print Layer Workflow Manually," repeat steps 1–5 exactly as you performed them. When you are finished, click the Stop Playing/Recording icon at the bottom of the Actions palette.

7. To save the new set and Action, first click the set folder in the Actions palette. Then click the arrow in the upper-right corner of the palette, and choose Save Actions. In the Save dialog box navigate to the Photoshop Actions folder (inside the main Photoshop folder on your hard drive and inside the subfolder, Presets).

The Action can be saved anywhere you like, but if you save it in the Photoshop Actions folder, it will show up at the bottom of the list when you next click the arrow on the Actions palette.

Once you have correctly recorded and saved the Action, open an image that you have optimized for contrast and detail and click the Play Selection icon at the bottom of the Actions palette. This sets up the digital fine print layer workflow Action in the Actions palette.

Notice the two columns of checkboxes in the Actions palette. Under ordinary circumstances, the boxes in the left column should all be checked and the boxes in the right column should be unchecked. This ensures that the Action plays without stopping.

Proof Setup, Overall Contrast, and Color Balance

Now that you've set up the digital fine print layer workflow (either manually or as an Action), it's time to use it to adjust the proof setup, overall brightness and contrast, and overall color balance of your image. For RGB images, you can correct both the overall contrast and color balance in three simple steps by using each color channel in the Levels window. For black-and-white images, you adjust just the overall contrast in the single grayscale channel.

In this chapter, you will adjust and evaluate the following:

- Proof setup
- Levels
- Overall brightness and contrast
- Overall color balance

You will also use the Layers palette.

Proof Setup

If you are printing using an inkjet printer from your computer desktop, you need to view the image in the correct proof setup, or *profile*, to ensure that the features of the image onscreen match the features of the printed image. Many photographers advocate making the proof at the end of the workflow, but there is a compelling reason for doing it at this point instead: You need to view the image *as it will be printed* before you balance its overall color. If you don't view the proof before color balancing, you'll be balancing the color twice—once for the color working space (Adobe RGB 1998) and again for the profile in the Proof Setup dialog box.

First, you need to make a copy of the image (choose File | Duplicate) so that one image is manipulated in the color working space and the other is used for the profile with which you need to print. Put both copies in the folder you made for this photograph.

Open Photoshop and an image:

1. Choose View | Proof Setup | Custom. The Customize Proof Condition dialog box appears.
2. From the Device to Simulate drop-down menu, select the appropriate ICC Profile for your paper and ink; in this example, Epson enhanced matte paper with matte black ink (MK) is chosen.

3. Choose the other options in the Customize Proof Condition dialog box, as follows:

- **Preserve RGB Numbers:** Do not select
- **Rendering Intent:** Perceptual
- **Black Point Compensation:** Select
- **Simulate Paper Color:** Do not select (for LCD monitors only)
- **Preview:** Select

4. Click Save and name the profile in the Save As field of the Save dialog box.

5. Click Save, and your saved profile will appear at the bottom of the menu when you choose View | Proof Setup.

Levels

Levels are used to adjust the overall contrast, brightness, and color balance of a photograph by finding the lightest and darkest areas of the image. Adjusting the interactive sliders in the Levels window (available from the Layers palette) allows you to make the best possible *overall* image. For traditional photographers, you can think of this as being similar to trying to find the correct contrast filter for enlarging a negative in black-and-white photography. (You'll learn about local controls, such as burning and dodging, in the next chapter.)

Adjusting overall contrast and brightness in a black-and-white photograph lets you accomplish two things: determine where the darkest and lightest tonal values will be, and adjust the *separation* of the midtone values between the darkest and lightest values. A good black-and-white print depends on the correct placement of the white and dark values so that all detail can be seen in the photograph, and good midtone value separation gives a print life and tonal substance. Notice in Figure 8-1 that the midtones all run together as muddy gray values, and the high values and low values are weak with no brilliance or contrast. In Figure 8-2, the midtone values are separated and the high and low values are corrected. The corrected image truly shows a forest glen on a sunlit morning.

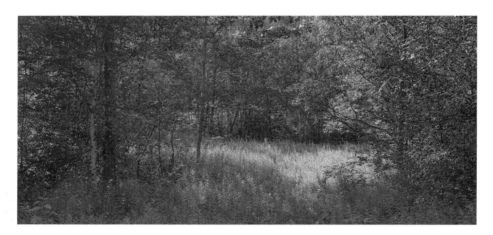

Figure 8-1: Forest glen image without corrected high, low, and midtone values

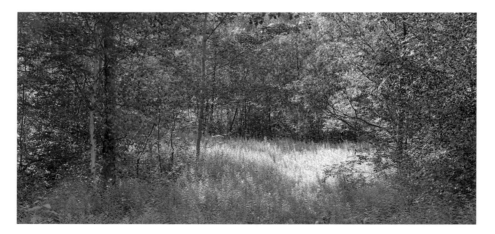

Figure 8-2: Forest glen corrected to show contrast

Adjusting overall contrast, brightness, and color in a color (RGB) image allows you to make the same adjustments you can make to a black-and-white image; it also allows you to correct any overall color cast that appears in the image. As mentioned in Chapter 3, a color cast is a color that permeates the entire image, as if it is viewed through a color veil. Color cast taints the natural colors of the objects in the photograph toward the problematic color. The color adjustment normalizes or balances the colors and removes this color cast so that all colors appear truer and more natural. Figure 8-3 shows a blue color cast created by using the wrong white balance setting in the digital camera. Figure 8-4 shows correction for color balance, contrast, and brightness.

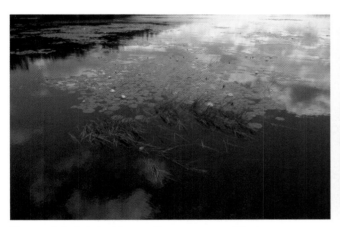

Figure 8-3: Original image from camera with strong blue cast

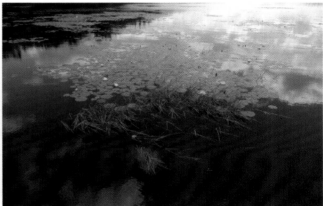

Figure 8-4: Image corrected for contrast, brightness, and color balance

The Levels Histogram of the Levels window is a graph showing the *tonal content* of your image. The horizontal axis shows the number of levels (tonal values) from black to white. The vertical axis represents the percentage of pixels (or the amount of each tonal value) at each level, from 0 to 100 percent.

You use the Input sliders (represented by the black, white, and gray arrows just under the Histogram; see the following illustration) to adjust the overall contrast and color. The left Input slider represents the black (darkest) point of the photograph. Any pixel to the left of that point will be totally black. The right Input slider represents the white (lightest) point of the picture. Any pixel to the right of the white point slider will be totally white. The middle Input slider adjusts the gray (midtone) separation and brightness.

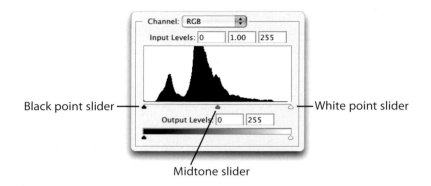

Black point slider — White point slider

Midtone slider

Let's look at some examples. These are not meant to be interpreted as "good" or "bad"; they simply show how different photographs appear with their Histograms.

Snow Storm, Sierra Nevada, shown in Figure 8-5, has a fairly even range of black, white, and midtone values throughout the print. The style and even spread of values from black to white and superb midtone separation in this image are typical of the great black-and-white landscape photographs of the twentieth century.

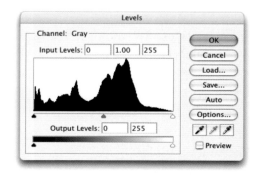

Figure 8-5: *Snow Storm, Sierra Nevada* and Histogram

Deep Woods, in Figure 8-6, shows a predominant collection of pixels at the low and lower midtone values with almost no high values. This is called a *low-key* setting.

Figure 8-6: *Deep Woods* and Histogram

Bark Design, Figure 8-7, shows almost all midtone and high values in the Histogram. This is called a *high-key* setting.

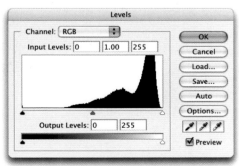

Figure 8-7: *Bark Design* and Histogram

139

Trees, Devil's Garden, in Figure 8-8, shows a bell curve–type Histogram and indicates that an abundance of pixels are clustered in the middle level ranges, tapering off to a few pixels in the highlights and shadows.

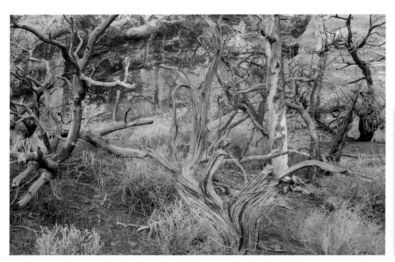 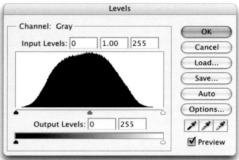

Figure 8-8: *Trees, Devil's Garden* and Histogram

Watercolors, Figure 8-9, shows almost all of the pixels represented in the midtone areas of the picture, with no black or white values.

Figure 8-9: *Watercolors* and Histogram

Arches Sunset, Figure 8-10, has a range of black, white, and midtone levels. The black spike represents the silhouetted sandstone formation; most of the sky is represented in the midtone region, and the highlight spike is the large white cloud.

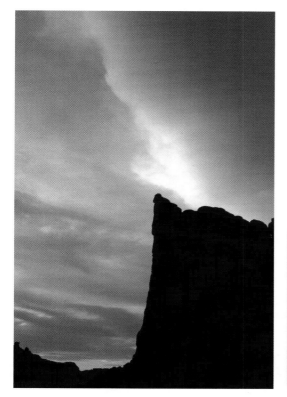

Figure 8-10: *Arches Sunset* and Histogram

Levels used to get a lot of bad press. The problem with levels was that 8-bit images corrupted quickly, and the "Fingers of Death," or gaps indicating lost or corrupted levels (tonal values), showed up rapidly in the Histogram (see Figure 8-11). With 16-bit images, this problem basically no longer exists (see Figure 8-12), because instead of having only 256 levels, as in an 8-bit image, a 16-bit image has more than 65,000 levels. This means that you can fiddle around in Photoshop a bit to fix levels, because the much larger number of levels protects the image from corruption (lost values). I've found that when working with the best possible image (as far as dynamic range is concerned) in 16 bits, which you can work with in Photoshop CS2, adjusting levels is a legitimate and powerful means to get the job done quickly and efficiently.

 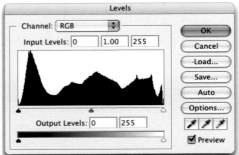

Figure 8-11: An 8-bit Levels Histogram shows effects of white, black, and midtone correction, the "Fingers of Death" (white vertical lines indicating lost values).

Figure 8-12: A 16-bit Histogram of the same image shows the same correction with no "Fingers of Death."

Adjusting Overall Contrast and Brightness in Black-and-White (Grayscale) Images

You should adjust the black (darkest) and white (lightest) points of a black-and-white (grayscale) image, because doing this fine-tunes the overall contrast. Take a look at the following black-and-white image and its Levels Histogram. Notice the lack of contrast and midtone separation before correction.

 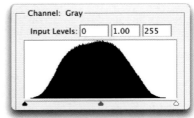

1. Hold down the OPTION/ALT key and click the black Input slider. The image turns entirely white.

2. If you move the black Input slider slightly to the right, pixels eventually show up as black spots in the image (these are the first dark values of the image).

3. When you find this place, move the slider slightly to the left, until no pixels are visible and the screen is completely white again. Then release the OPTION/ALT key.

4. Do the same with the white Input slider by moving it to the left while holding down the OPTION/ALT key. The screen turns black this time, and white pixels (the first light values of the image) begin to show up.

5. While still holding down the OPTION/ALT key, move the slider to the right until no pixels are visible and the screen is completely black again. Then release the OPTION/ALT key.

6. For a brightness correction, if necessary, adjust the midtone Input slider slightly to the right to make the image darker and slightly left to make the image lighter. For a black-and-white image, this is all you need to do to fine-tune overall contrast and brightness. At right is the image corrected for contrast and brightness.

Adjusting Overall Contrast, Brightness, and Color in Color (RGB) Images

Correcting overall contrast is easy to do for an RGB color image; however, instead of adjusting the white and black points on one Gray channel, you adjust them on the *three* Red, Green, and Blue channels individually. In addition to correcting the overall contrast, the three individual RGB channel corrections also fix the overall color balance of the image. Watch how this happens.

Take a look at the original 16-bit color digital photograph called *Oak and Slickrock*. Notice how flat (low contrast) the picture looks because it was photographed in very soft sky light, with an overall bluish (actually it's more cyan than blue) cast from the sky light. The midtones are not well separated. I've also included a black-and-white conversion of the image so you can see the flat nature of the image and the weakly separated midtones, and a Histogram showing the RGB color levels.

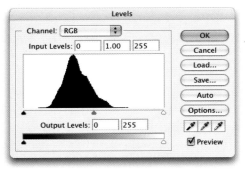

1. On the Overall Contrast & Color layer in the Layers palette (choose Windows | Layers), double-click the white rectangle with the miniature histogram in it. This opens the Levels window.

2. Above the Levels Histogram, you see Channel: RGB. Click the arrows to the right of the field and scroll down to Red.

3. Hold down the OPTION/ALT key and drag the black Input slider to the right; the screen will turn red. Keep sliding until black pixels begin to appear.

Then drag slightly to the left so that no pixels appear and the screen is entirely red.

4. Hold down the OPTION/ALT key and drag the white Input slider to the left until red pixels begin to appear; this time, the screen will be black.

Drag the slider slightly to the right so that no pixels show.

5. Click the arrows to the right of the Channel field and choose Green. Repeat steps 3 and 4.

Moving the black Input slider to the right while holding down the OPTION/ALT key turns the screen green with black pixels.

Moving the white Input slider to the left while holding down the OPTION/ALT key turns the screen black with green pixels.

6. Choose the Blue channel and repeat steps 3 and 4.

Moving the black Input slider to the right while holding down the OPTION/ALT key turns the screen blue with black pixels.

Moving the white Input slider to the left while holding down the OPTION/ALT key turns the screen black with blue pixels

7. Choose the composite RGB channel and adjust the midtone Input slider to the left to lighten the image; move it to the right to darken it. Here's the image after the RGB color channels have been adjusted:

> **Note**
>
> Remember that brightness (luminosity) is not a function of *color* but of *value*. Brightness exists only in black and white, even though you may see it working in a color image. As a result, it's best to adjust the overall brightness in all channels at once with the midtone Input slider in the master RGB channel (as was done in step 7) rather than in each individual channel.

Caution: Use Good Sense When Adjusting Levels

Sometimes an image defies color adjustment. In such a case, you can visually adjust the Levels sliders. This is especially true when *noise* is present in the Histogram. Noise shows up as a horizontal line at one or both ends of the Histogram, as shown in the first image below. To fix the problem, it is safe to adjust the Input slider on the main part of the Histogram, as shown in the second image, and disregard any pixels that show up when you hold down the OPTION/ALT key.

Noise
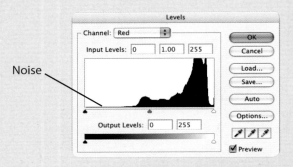
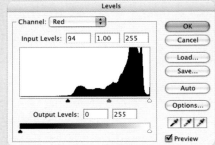

The following sequence shows the uncorrected image, the corresponding Red, Green, and Blue Histograms with the noise adjusted, and the final corrected image.

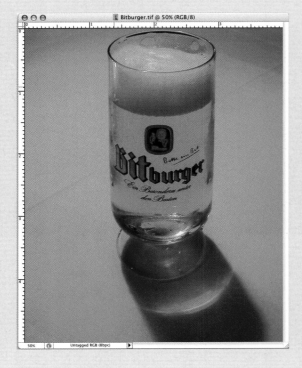

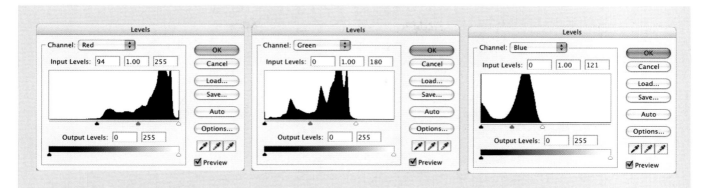

In addition to overriding the standard procedure for adjusting contrast, brightness, and color, you can click Options in the Levels window and explore the various combinations of features in the Auto Color Correction Options dialog box to determine whether your image can be improved. I have found that choosing Find Dark & Light Colors coupled with Snap Neutral Midtones is most useful. This gives you more choices to evaluate color.

Evaluating the First Print

At this point, you may want to make a print of the photograph to evaluate for color, contrast, and brightness. After you've printed the image using one of the workflows discussed in Chapter 11, examine and evaluate it in terms of brightness, contrast, and color balance. Refer to Chapter 2—and also, especially, read the following information that refers directly to brightness, contrast, and color balance.

Correctly evaluating contrast and brightness involves three image factors: highlight detail, shadow detail, and midtone value separation. Strictly speaking, all objects in our world have detail in them. The only things that don't have detail are ambient light sources such as the sun or light fixtures and their reflections, and they can be rendered as pure white. Black is trickier, though. In a photograph, you usually want to see detail all the way down into the deepest shadows, but you also need (most of the time) a 100 percent black with which to "key" the other values. Often, your print doesn't need much black at 100 percent—just a touch somewhere. The biggest giveaway to poor contrast is blank white highlights and vacant black shadows—the "Soot & Chalk" effect, as Ansel Adams used to call it. Figures 8-13 and 8-14, respectively, show how improper contrast can affect an image and how corrected contrast can revive it.

Figure 8-13: "Soot & Chalk" effect here; highlights are washed out and shadows are black and vacant.

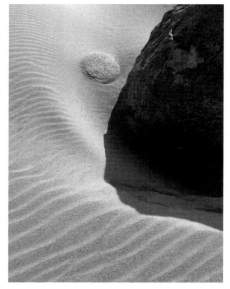

Figure 8-14: This is the same image, but highlights, shadows, and midtones have been corrected.

Poorly separated midtones are also a dead giveaway of improper contrast in images. Figure 8-15 shows a black-and-white image with poor midtone separation, and Figure 8-16 shows the same picture with the midtones corrected (using the Levels technique covered in this chapter) for good separation.

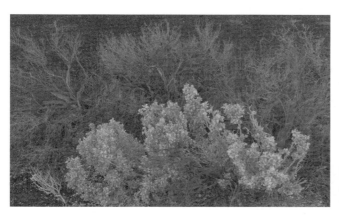

Figure 8-15: Uncorrected black-and-white image with poor midtone separation

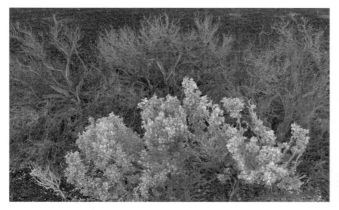

Figure 8-16: The corrected image shows good contrast.

With brightness, I'm always looking for a mood, feeling, atmosphere, or ambience. Brightness is more of an overall enveloping sense of the light that permeates every corner of the image rather than being related to any specific tone or object. Brightness is the glue that holds the image together, almost always in a way that seems invisible to us. One might call it *ambient light*. We will tackle brightness directly by adjusting local contrast, but first we need to choose an image that conveys the best overall "feeling" of the ambient light. Here's a clue: Does the print "glow"? That's your brightness. By adjusting the midtone Input slider in the Levels window, you can adjust this "feeling" of the light to make it lighter or darker.

Setting the Grays

One way to evaluate and adjust the contrast and brightness in an image is to use a diagnostic tool I devised just for this purpose. It mimics the procedure in Adobe Camera Raw for correcting the luminosity in both black-and-white and color images. It allows you to work with the black-and-white parts of a color image—the *luminosity*—to set the highlights, shadows, and midtones properly. In addition, this procedure also helps to balance the overall color. I call it "Setting the Grays." It seems a bit complex at first, but it requires only close attention.

1. In the digital fine print layer workflow, click the Local Contrast & Color layer and duplicate it by dragging it to the New Layer icon at the bottom of the Layers palette (⌘-J/CTRL-J). A copy of the layer will appear over the original.

2. In Photoshop, choose Image | Adjustments | Desaturate (⌘-SHIFT-U/CTRL-SHIFT-U). This turns the images into a temporary grayscale version.

3. Create a curves adjustment layer by clicking the Create New Fill or Adjustment Layer icon and selecting Curves.

Create New Fill or
Adjustment Layer

4. Adjust the curves to give the highlights and shadows good detail and good separation in the midtone values. (Refer to the sidebar, "Curves Primer," at the end of Chapter 4.)

153

5. Click to unselelect the Eye button on the desaturated layer (Local Contrast & Color copy) to see the adjusted color image.

6. Drag the desaturated layer to the Trash Can icon at the bottom of the Layers palette.

7. Select the curves adjustment layer (Curves 1), click the arrow at the upper-right corner of the Layers palette, and choose Merge Down. You've now set the grays, and the image should look much better.

The following shows the image before the grays were adjusted (left) and after (right):

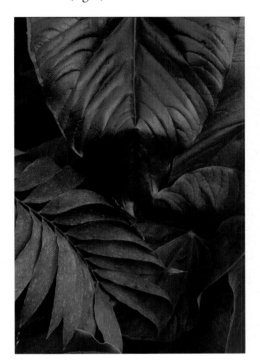

Evaluating Color Balance

The evaluation of color balance is totally subjective. For fine art images, there are no hard-and-fast rules; what you can correct is your relative interpretation of the picture. Minor White, the great twentieth century photographer and teacher, called this "The Interpreted Real," meaning that the interpretation of the image in print may not look exactly as it did in reality. The image is *interpreted* with tonal and color changes to represent what the photographer "felt" about the scene rather than just the way it looked. This interpretation may take on subtle or very observable changes in a photograph, but it's all about expressing what you felt *and* saw when you snapped the shutter. Remember that color is relative.

Consider overall color cast, for example. (See the upcoming sidebar, "Fixing a Slight Color Cast.") Color cast can involve any color—or even two or three colors. To fix color cast, you must diagnose which color(s) is problematic and use the complement to neutralize or correct it. Usually, color cast problems can be handled well with Adobe Camera Raw's white balance settings. The overall contrast, brightness, and color layer adjustments should help even more, but in case you still see problems with overall color cast (and such problems are usually slight), you can use Color Balance to fix them.

> **Note**
>
> The diagnosis of a color cast is far more difficult than the repair. It can be difficult to determine whether a color cast is too red or too magenta, or too yellow or too green, for example.

Once you've adjusted the overall contrast, brightness, and color it's time to go on to the Local Contrast & Color adjustment layer and work on the all-important issues of burning, dodging, and any other local controls that are needed. We'll cover that in the next chapter.

Fixing a Slight Color Cast

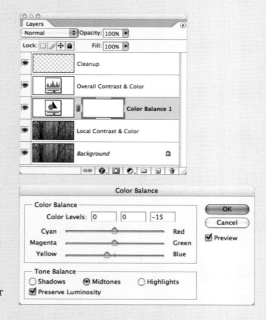

1. In the digital fine print layer workflow, select the Local Contrast & Color layer and above it create a Color Balance adjustment layer by clicking the Create New Fill or Adjustment Layer icon at the bottom of the Layers palette and choosing Color Balance. Determine which color is causing the color cast, and in the Color Balance window select the slider that represents both the problematic color and its complement. Move the slider carefully toward the complementary color until the cast is eliminated. You may need to make adjustments for the highlights, shadows, and midtones by clicking the appropriate buttons in the Color Balance window.

2. When you are finished, select the Color Balance adjustment layer, click the arrow at the upper-right corner of the Layers palette, and choose Merge Down. You may also need to make adjustments with more than one complementary color set. This can be difficult to master, but it gets easier with practice.

The top image at right shows a bluish color cast. And the bottom image shows the color cast removed by adding Yellow (–15 Yellow) in the Color Balance window.

Tip

I use iCorrect EditLab Pro (www.picto.com) to help fix color problems. It corrects overall color casts better than many of the other color plug-ins available for Photoshop, and I recommend it for use on difficult images. Remember that your best protection against overall color casts is by using Adobe Camera Raw and its excellent white balance adjustments. Color balance issues are another reason to photograph using RAW.

Local Contrast and Color

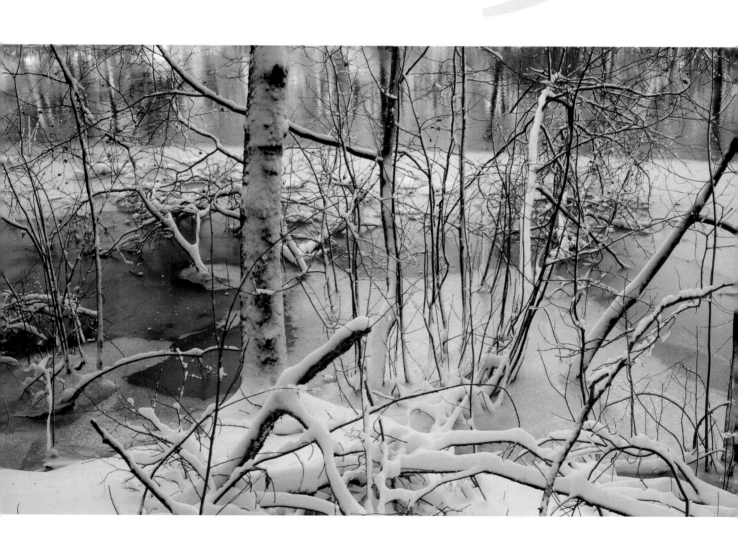

What you will learn and adjust in this chapter:

- History brush
- History palette
- Use of selected modes for blending and opacity levels
- Local brightness and contrast correction (burning and dodging)
- Outlining
- Local color improvements

Here are the palettes you will use:

- Brushes
- Layers
- History

Mastering digital photography is sort of like mastering the game of golf. Some say that you can become a better golfer simply by using the best equipment. Others say golf is a game of skill, and the technique of how you apply the club to the ball is all important. Still others say that practicing long, continuously, and often gives you a better golf game. I believe the last sentence contains the most truth, and that the same truth holds for art and photography. We all know that the best equipment theory is sheer baloney. And although technique is important, it's not the only way to get ahead in the vast arena of photography (or golf). Of course, you need a modicum of technique and fairly good equipment, but your real saving grace will be your determination to practice and practice and practice. Just ask Jack Nicklaus, Michael Jordan, Joyce Tenneson, Earl Scruggs, or my son, the golfer.

In this chapter, I demonstrate the use of one tool that does many things: the History brush. The History brush is more of an attitude than a technical tool. Let me explain. Artists, when they make a mark (a brush stroke), or photographers, when they make a print, move forward in a positive, courageous way. We rely only on our intuition and craft to bring us to the final, successful destination that is the painting or print. If the artwork doesn't turn out the way we want, we erase it, or cover it up, or throw it in the trash can, and try again. We may do this five to twenty or more times until the work is finished. It is a matter of iteration, back and forth, back and forth.

The key to this process is *perception*, not a technical trick. If you can't see the problem—brightness, contrast, color, softness, sharpness, or

whatever it is—then no technique in the world will make your print better. Not one. This is the basic problem I face every time I teach Photoshop and the Digital Fine Print Workshop. And even after I emphasize the fact that perception and problem diagnosis are more important than any technique, people still don't get it (even intelligent people), and they end up in "technique hell," wondering why their photographs don't turn out well. If you get just this one idea out of reading this book, then I've done my job, and this knowledge alone will have been worth the purchase price.

Applying and refining one technique to a myriad of printing problems is the best way to learn about perception. This gives you a yardstick by which to measure success, and you don't have to worry about how many tools you know. Perception and refinement of one or two techniques make the best print. I know a photographer who uses only Levels and Curves, and his photographs hang in major galleries. His greatest asset is that he was a black-and-white photographer for 30 years and he knows tonal values up one side and down the other, so he can see everything that happens in the print. Everything. Ansel Adams and Minor White, two of the greatest printers in the history of photography, used traditional burning (local darkening) and dodging (local lightening), refined to a high degree, to produce their masterpieces.

The History brush, the long-lost tool of Photoshop, is such a powerful solution to almost all local digital printing problems, that I rarely use selections and masks anymore. The History brush is faster, more intuitive, more artist- and photographer-friendly, and easier to use than the host of tools that accomplish the same thing, especially layer masking.

History Brush vs. Masking

Masking is a great tool, especially for photographic retouchers and graphic artists who need many layers and need to keep track of their work exactly. But masking fails in the making of a digital fine print largely because it is counterintuitive to an artist to subtract something (which is what painting on a mask does) and then save it to go back and fix it. When producing prints or artwork, artists and photographers are accustomed to performing a progressive series of forward movements.

Cutting a mask means that you are afraid to make a real move, and having cut the mask, you must live with it or trash it. You have to be

willing to submit to this very heartrending process of forward movement without hesitation, or the work will look mechanical and not authentic. In other words, overmasking can create the look of a print created using a technique, rather than one created with artistic skill.

The History brush, on the other hand, works like a real tool an artist or photographer uses. It lets the artist paint a correction relayed by perception—instantly, with no hesitation, positively, and in a progressive forward direction. It allows only limited retreat to previous versions (or states) that also gives it the artist's mark of authenticity. In the digital fine print layer workflow, the Local Contrast & Color layer allows us to save the refined image, so that, if we need to, we can go back and continue to work on it from that last saved refinement.

One of the debates about masking versus the History brush is that Layer Masks on adjustment layers in Photoshop are nondestructive. The History brush, because it paints directly on the pixels of the Local Contrast & Color layer, is called *destructive* because it alters the pixels every time you use it to paint. What is lost in the debate is that the photograph has to be flattened when you go to print, and this pixel destruction will occur with either masking or the History brush—hence, my emphasis earlier on having the best image you can possibly make going into Photoshop in the first place.

I cover only the History brush in this book because I'm an artist and photographer, and I like very simple technical solutions to complex visual problems. If you want to learn more about masking, I recommend without hesitation Katrin Eismann's book, *Photoshop Masking & Compositing* (New Riders Press, 2004). Katrin *is* the best.

Basic History Brush Technique

 The basic History brush tool as I use it consists of the brush itself used on the Local Contrast & Color layer of the digital fine print layer workflow. I employ the brush using only the Mode and the Opacity settings on the Options bar.

I use two modes for basic lightening (dodging) and darkening (burning) local areas: Multiply for burning and Screen for dodging, both set at various opacity percentages using the Opacity setting. See the upcoming sidebar, "Blending Modes," for more information.

Blending Modes

Blending modes is the way Photoshop combines one layer with another. You usually work on the top layer, and it "blends," or combines, with the layer below with various effects. You can lighten and darken, increase and decrease contrast, and perform many other useful adjustments. The problem is, they work in peculiar ways that are difficult to understand, and I see most people shy away from using them as a result.

The explanations I provide here deal only with the effects of the modes I find most useful for editing photographs. It assumes that you are going to combine the image with itself in different ways, just as you would in the traditional darkroom by burning and dodging a negative to lighten and darken local areas in the print. I suggest you study these illustrations carefully and remember how they look, because they are your key to adjusting local areas in the image with aplomb. I use the following modes most often (you can play with the others to see if they work for you).

- **Normal** This is what the top and bottom layer look like, as illustrated by the two grayscales, when Mode is set to Normal. The top and bottom layers are identical (the top layer is just a copy of the bottom layer).

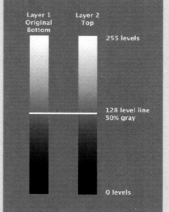

- **Multiply** Notice how the top layer in Multiply mode is darker than the bottom layer. I use this mode to darken, or burn, local areas with the History brush tool. Also notice how the top layer changes little at the top of the grayscale (extreme whites). This works exactly like the physical darkroom procedure of burning—it always takes much longer to burn the high values than the low values because of the varying densities of the negative. This suggests that it's difficult to burn white areas because neither the top layer nor the bottom layer changes. I'll show you how to do this when I cover the Normal (Inverse) mode.

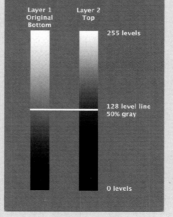

(continued)

Blending Modes *(continued)*

■ **Screen** Here the top layer in Screen mode is lighter overall than the bottom layer. I use this to lighten, or dodge, local areas. Just as in Multiply mode it is difficult to burn very high values, so in Screen mode it is difficult to dodge very dark areas, just as with real dodging in the darkroom. However, using Normal (Inverse), we can do this.

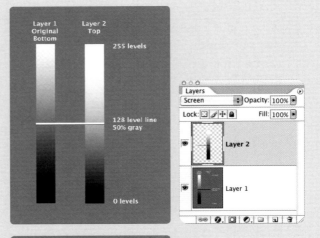
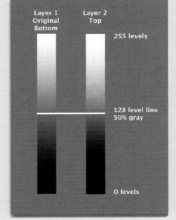

■ **Overlay** Overlay mode increases contrast, but in a special way. It lightens the levels above level 128 (50 percent gray) and darkens the levels below level 128. This is important, because when you want to increase contrast locally, you'll have to have both levels above and below 128 for the Overlay mode to work. Otherwise, if all light levels are above 128, they will only lighten, and if all levels are below 128, all they will do is darken.

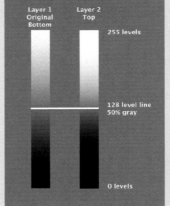

■ **Soft Light** Soft Light mode is similar to Overlay mode in that it increases contrast, but the effect is less pronounced. Compare the two visually.

- **Normal (Inverse)** Normal (Inverse) is nothing more than the top layer inverted as a negative using Image | Adjustments | Invert. It is exactly the opposite of the bottom layer. Normal (Inverse) is useful in the technique described in "History Brush 103," later in the chapter, because it allows us to paint with a Snapshot made on the History palette. As you can see, the darkened top and lightened bottom will now allow us to burn the extreme highlights and extreme shadows with ease.

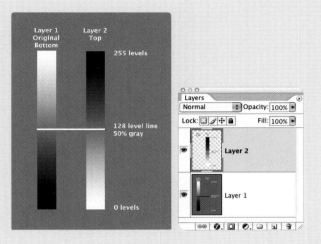

- **Overlay (Inverse) and Soft Light (Inverse)** Inverting the top layer and applying either Overlay or Soft Light (shown here) mode decreases the contrast of the image and can be useful in an overall sense, to decrease the contrast of the whole picture, or decrease it in local areas with the History brush. I usually use this mode with extremely low opacities, often less than 20 percent.

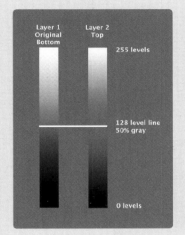

(continued)

Blending Modes *(continued)*

The following images show an example of how the Soft Light (Inverse) on the top layer reduces the contrast of the image and brings out the shadows.

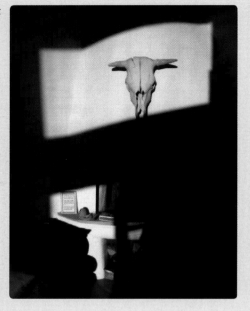

The original image

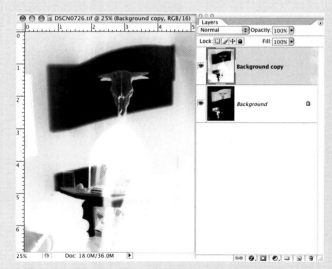

Inverted second layer with Normal mode

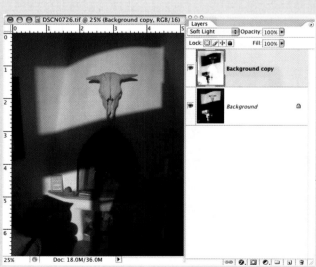

Inverted second layer with Soft Light mode

History Brush 101

Let's adjust the local brightness and contrast of an image.

1. Open an image and apply the workflow as discussed so far. The following image has been optimized and corrected for overall contrast and color. Choose the Local Contrast & Color layer so the History brush will work.

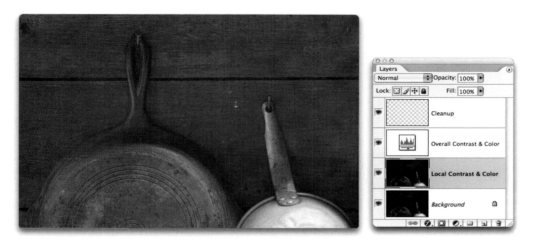

This photograph, one of the notorious DeWolfe burn-and-dodge exercises from hell, is a full-scale image, from black to white, yet it needs a lot of lightening and darkening in places to make the frying pan more visible and pronounced, to bring the aluminum pot down in brightness, and to accentuate the wood grain to stand out more in contrast so that we can see the detail. The image has been combined from a nine-exposure bracket in the Optipix Show Average tool. Let's work on lightening the frying pan and pot first.

2. Click the History brush tool and choose Screen from the Mode pop-up on the Options bar, and set the Opacity to about 50 percent (it takes practice to judge the amount of opacity, but catching on to this is easy). The size of the soft brush is adjusted by pressing the right bracket key (]) for a larger brush or the left bracket key ([) for a smaller brush. What you should see

right away is that the frying pan and pot need to be separated from the background, so you can paint in the places necessary, mostly around the edges, where the pan and pot are next to the wood, and also the handles and some of the highlight details on the frying pan.

3. While still in Screen mode, separate the wood grain on the wall by selecting the lightest spots and slightly lightening them. Use a very small brush for this and work quickly and selectively over the wood without paying much attention to specific areas. Screen mode is used to its best advantage here, because it will lighten lighter areas quicker than darker ones. This process is a sort of "dry brushing" with the Screen mode.

4. Now switch to Multiply mode and do exactly the same thing to the dark areas of the wood that you did to the white areas. Selectively darken some of the areas of the frying pan and accentuate the dents in the pot. The result now looks very close to what I envisioned.

5. If you look really closely, you get a gut feeling that the contrast is not quite right. Whenever I get this feeling, I usually apply Optipix Auto Contrast (*not* Photoshop's Auto Contrast, which clips the high and low values too much) with a 0.01 Tail Clip and Linear 50 percent Point.

And here is the final adjusted image:

This is the basic History brush in action. For local contrast and brightness control, it has no peer. However, as Adobe's peerless Julianne Kost would say, "But, wait, there's more!"

History Brush 102

This second technique is perhaps the way the History brush was used when it was first introduced. The History brush in this example combines with the History palette and Snapshots to paint a local correction on the image. Using this technique, you can apply any correction, filter, tool, or adjustment in Photoshop as a local correction.

Here is a detailed outline of the second History brush technique:

1. Apply Curves, Levels, Hue/Saturation, Color Balance, and so on, to the entire photograph, but pay attention only to what is happening to the area you want to change in the image. (Note: You must make the correction from the Menu bar, not from an adjustment layer.)

2. Open the History palette and make a Snapshot by clicking the camera icon at the bottom of the History palette. Make sure you are on the Local Contrast & Color layer of the digital fine print layer workflow.

3. Scroll to the top of the History palette and assign the History brush to the Snapshot by clicking the square to the left of the Snapshot layer.

4. Highlight the second-to-last History state (the one before the correction).

5. Select the History brush in the Toolbox and choose a brush size.

6. In the Options bar, make sure the Mode is set to Normal and the Opacity is 100 percent.

7. Apply the correction using the History brush.

Here's an example that combines the use of Curves with Snapshots and the History brush:

1. This photograph near Sam's Gap in Tennessee is fine in overall contrast, but the middle-ground trees need to be increased in contrast.

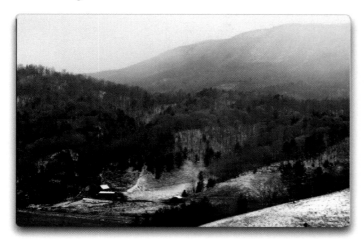

2. After selecting the Local Contrast & Color layer, from the Photoshop menu I choose Image | Adjustments | Curves and increase the contrast so that the middle-ground trees look better. (Refer to the sidebar, "Curves Primer," at the end of Chapter 4.) The whole picture will change, as you can see here by the increased contrast, but I'm just paying attention to the trees.

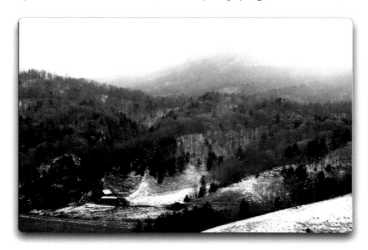

171

3. Here I've made a Snapshot of the Curves correction in the History palette. The square next to the Snapshot layer shows that the History brush has been assigned to it.

Create New
Snapshot

4. Now I highlight the second-to-last History state. (The highlight color here is golden yellow, but it may be different on other computers.)

5. I select the History brush in the Toolbox and make sure that the Mode is set to Normal and the Opacity is set to 100 percent. (These can be changed to other modes and opacities, but I want to apply the Curves correction just like I made it.)

Here's the final image with the Curves adjustment painted with the History brush on the middle-ground trees.

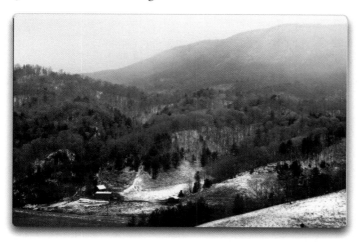

This is just one example of the infinite number of corrections, filters, color changes—almost anything—that can be painted locally using this versatile tool.

> **Note**
>
> If the History brush shows up as a circle with a line through it (telling you that it won't work), you can investigate three possible reasons:
>
> ■ *The Local Contrast & Color layer is not selected.* Select it if it's not selected, because the History brush doesn't work on the other layers of the digital fine print layer workflow.
>
> ■ *The last History state is not checked.* Scroll down the History palette to the end of the History states and check the last box next to the last History state.
>
> ■ *As a last resort, save the file, close it, and open it again immediately.*

History Brush 103

Another way to use the History brush employs Snapshots of the overexposed and underexposed images (taken as a bracket in Adobe Camera Raw). These Snapshots, when they are dragged into the normal exposure window, show up as two new Snapshots in the normally exposed image's History palette. It looks like this:

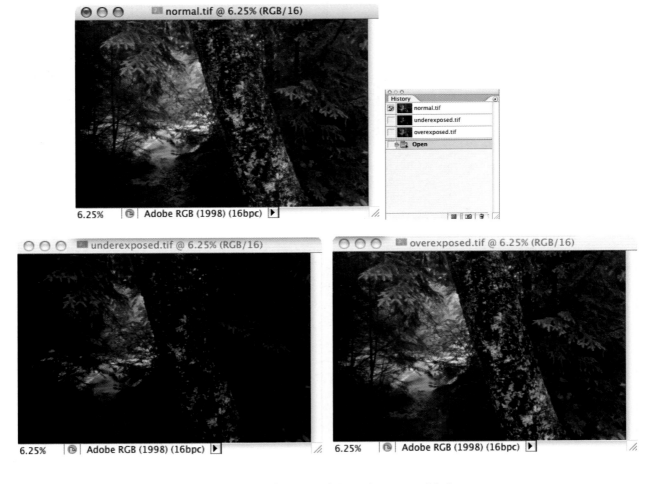

Once the overexposed and underexposed Snapshots are added to the normal exposure window, they can be used to paint on the normal exposure image to lighten and darken the image locally, using the History Brush 102 technique described earlier.

Here are the original image (left) and the final image that has both the overexposed and underexposed Snapshots painted locally on the normal exposure image.

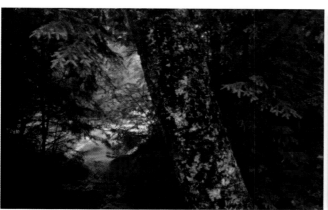

Outlining

Outlining is a special use of the History brush that I devised to separate objects from one another as well as create a web of light that holds the image together as a whole. This fits my ideas about being the conductor of the print, trying to make individual objects be themselves and, at the same time, combining the objects into a unified image. I use the History brush as I described in "History Brush 101," but I use a very small brush, usually in Multiply mode at a low Opacity setting. The effect makes an object stand out, yet keeps it within the image as part of it. The basic technique is to use a small brush to darken the edge between the object and its background. Occasionally, I'll use Screen mode to lighten the edge of the object to separate it.

Figure 9-1 shows a black-and-white image, and Figure 9-2 shows the same image after burning and dodging with the "History Brush 101" technique and outlining. Figures 9-3 and 9-4 demonstrate the same techniques applied to a color image.

Figure 9-1: Original image

Figure 9-2: After burning, dodging, and outlining

Figure 9-3: Original image

Figure 9-4: After burning, dodging, and outlining

Using outlining can be beneficial, and it's worth the time to do it if needed. One of these benefits is an increase in the sense of ambient light that I talked about in Chapter 3.

Local Color Improvements

What I call local color improvements refer to mostly saturating and desaturating local colors that seem too weak or strong respectively. Here, again, diagnosis of the problem is critical to success in adjusting it.

Hue/Saturation

I frequently emphasize colors using Hue/Saturation (Image | Adjustments | Hue/Saturation), choosing each individual color from the Master pop-up, and visually adjusting the Saturation slider until I get what I want. I also use this in conjunction with the History brush locally to change the saturation of a color rather than all objects in the image with the same color, which is what Hue/Saturation is limited to in its control. See the "Hue/Saturation" section in Chapter 3 for a detailed description.

Figure 9-5 shows the original image, and Figure 9-6 shows the same image after Hue/Saturation, the "History Brush 101" technique, and some outlining have been applied.

Figure 9-5: Original image

Figure 9-6: After Hue/Saturation, History brush, and outlining adjustments

Sponge Tool

I employ the Sponge tool to increase or decrease color saturation locally, but I use it sparingly, because of its relationship to the very pixel-destructive Burn and Dodge tools that it lives with in the Photoshop Toolbox. Here's an example. This technique is detailed in the "Sponge Tool" section in Chapter 3.

For the image at the left, I needed to increase the saturation of the blues and lighten them a bit. The image at the right shows how the photograph was adjusted using the Sponge tool alone.

History Brush Examples

To show you what can be accomplished with the History brush and its fellow local contrast tools, here are some examples, before and after, explaining what tool was used in each.

History Brush Example 1 The first image shows the original black-and-white digital file, which is flat and uninteresting. In the second image, Levels have been applied and you can see some improvement in contrast. The final image was painted with the History brush in Multiply and Screen modes.

History Brush Example 2 The original image of a shell on a blue weathered board has been dramatically improved with the application of the History brush and after outlining has been performed.

History Brush Example 3 The first image in this sequence shows the original colored rock, as it was taken in the camera. The second image shows the adjustments I made using the History brush in Multiply, Screen, and Overlay modes, and in Levels. And in the final image, outlining, Hue/Saturation, and the Sponge tool have been applied.

History Brush Example from Hell 2 Remember the pot and fry pan burn-and-dodge exercise from hell earlier in the chapter? Here's another one. Working on the original image (shown at left) made me look at it like a conductor, because in order to make adjustments correctly, I had to pay attention to all the individual details and the whole at the same time. All the necessary corrections can be done with one instrument—the History brush. If you want to get a feeling of what painters go through, you should try something similar in color, using only the History brush and Sponge tools.

Final Preparation for Printing

In this chapter, you will learn and adjust the following:

- Using the Clone tool, Healing brush, and Spot Healing brush
- Saving a flat version of the image
- Noise removal and sharpening
- Interpolating images
- Edge burning
- Tweaking final contrast
- Converting to 8-bit for printing

You will need the following plug-ins:

- Optipix 3
- Noise Ninja

You will use these palettes:

- Layers
- Actions

After you've made the image look good, you need to attend to some final small duties before your masterpiece is unleashed upon the world. In traditional photography, this meant washing, drying, and spotting. *Spotting* was one of those rites of passage of any art that required consummate skill and patience with a Winsor & Newton Series 7 Kolinsky Sable watercolor brush. The Kolinsky sable is a Russian mink that slinks around in dreaded fear of artists, but photographers are no longer a threat. We have the Clone tool, the Healing brush, and (new to Photoshop CS2) the Spot Healing brush now. All of these tools eliminate dust, spots, scratches, and other defects (non-image forming content). They are pathetically easy to use, require little patience, and demand virtually no skill. These tools are used on the Cleanup layer of the digital fine print layer workflow.

After cleanup, you save the image as a new file (File | Save As) so that you retain the original four-layer workflow in case you want to retreat and fix something, and then you flatten the file. This will now give you four images (or maybe five) in the picture's folder:

- The original TIFF or PSD file
- A copy of the original file
- The file with the digital fine print layer workflow on it
- The flattened file with which you will print the picture
- If interpolation is necessary, you'll also have a fifth file.

Once the file is flattened, you'll remove noise, if any exists, and sharpen the image. I do these two functions together because they are the opposite of one another (noise blurs, sharpen sharpens). Noise removal and sharpening are among the most notorious, misunderstood, and worst-applied tools in Photoshop. Third-party software for sharpening alone comprises the single largest group of plug-ins for Photoshop, and the choices seem bewildering. I have seen sharpening workflows in magazines that comprise 12 steps to accomplish. My feeling has always been that noise removal and sharpening should be done like one makes a dry martini (a lot of gin, and just say "Vermouth" over the top of the glass)—not very much, in other words. I also believe in a simple one- or at the most two-step procedure that works on most images. This is possible with Noise Ninja and Optipix Safe Sharpen.

If the image needs to be enlarged, or interpolated, past its native file size and resolution as it comes from a RAW or JPEG file, you need "miracle" software. Basically, interpolation *adds* information to your image by using the pixels present in the original, comparing them to one another in various ways, and then applying that information to enlarge the image. This procedure is done in what is called a "visually lossless" way, which simply means that changes were made to the image to make the picture bigger, but you can't see these changes. Advertisers use this "miracle" software to blow up 35mm images to the size of the side of a skyscraper. I use two types of interpolation software: Fred Miranda's stair-step interpolation tool (SI Pro 2) and Optipix Interactive Interpolation. I'll demonstrate use of the latter in this chapter.

Many photographers who worry about these things often ask me why I don't sharpen after I interpolate (enlarge) the image. I confess that I worship many gods, and sometimes I'll sharpen both before *and* after interpolation, if the image needs it. Every picture is an individual child and must be treated separately, with loving care.

Three more small items need to be evaluated and adjusted before your print is ready for press: final edge burning, contrast tweaking, and changing from a 16-bit to an 8-bit image. Edge burn uses the Gradient tool to hold the image together by keeping the edges visually from "falling" outside the borders of the picture. I frequently find that the image is questionable, more intuitively than visually, in both overall contrast and edge balance. I use the Gradient Map (Image | Adjustments | Gradient Map) and the Fade window (Edit | Fade) to look at the contrast in an interactive way to confirm or deny

my suspicions about the contrast. Converting from 16 bits to 8 bits simply gives the printer an easier job of processing (spooling). Some printers or printer drivers (RIPs, as they are called) won't print 16-bit files, and besides, it's nearly impossible to tell the difference in printed form. We need the 16-bit heavyweight file only to protect the image from corruption while we're working on it in Photoshop.

Cleanup

I was going to give Cleanup a separate chapter all its own, but after thinking about it, I decided that the chapter would indeed be a short one. Almost everyone who reads this book is familiar with the Clone tool and the Healing brush. The Spot Healing brush, new to Photoshop CS2, is super easy to use.

The essential problem of cleanup is this: An unwanted spot is in the picture and it has to be eliminated. You have basically three choices, all found in the Photoshop CS2 Toolbox:

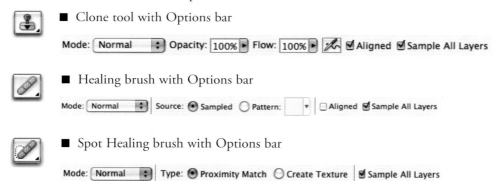

- Clone tool with Options bar

 Mode: Normal Opacity: 100% Flow: 100% ☑ Aligned ☑ Sample All Layers

- Healing brush with Options bar

 Mode: Normal Source: ● Sampled ○ Pattern: ☐ Aligned ☑ Sample All Layers

- Spot Healing brush with Options bar

 Mode: Normal Type: ● Proximity Match ○ Create Texture ☑ Sample All Layers

Both the Clone tool and the Healing brush require sampling (choosing) an area that you want to clone (copy) by holding down the OPTION/ALT key and clicking, releasing the OPTION/ALT key, and painting or spotting on the defect to get rid of it. The Spot Healing brush samples from the surrounding pixels automatically, so all you need to do is click the defect, and—miraculously—it disappears (most of the time). The Spot Healing brush is so easy to use that it's becoming the major defect removal tool in Photoshop. The following images show how it works:

Dust spot

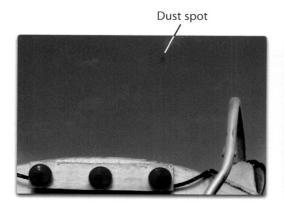

Click with Spot Healing brush

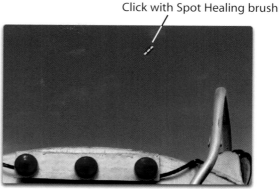

Spot gone!

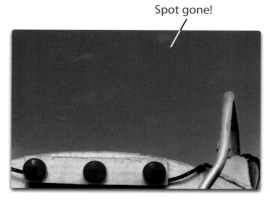

Using these tools involves some common caveats:

- Almost always use a soft brush.
- Always remove defects and dust while viewing the image at 100 percent or Actual Pixels (double-click the Zoom tool in the Toolbox).
- When the Cleanup layer on the digital fine print layer workflow is selected, check Sample All Layers in the Options bar. *This is the most common reason for any of the cleanup tools not working on the Cleanup layer.*

- When you *uncheck* Aligned (in the Options bar) when using both the Clone tool and the Healing brush, the sampled area stays the same. When you *check* Aligned, the sampled area moves with the brush cursor.

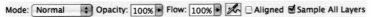

- When using the Healing brush, be sure Source: Sampled is selected in the Options bar. When using the Spot Healing brush, be sure that Type: Proximity Match is selected. Both of these will usually give the expected results.

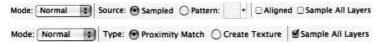

- If one of the cleanup tools doesn't work for a particular defect, try another one.

Saving a Flat Version of the Image

This is easy and fast, and you have to do it for consistent printing.

1. In the Photoshop CS2 menu, choose File | Save As.

2. In the Save As window, navigate to the picture's folder name, highlight it, and rename the picture *picture name* flat.tif. Click Save.

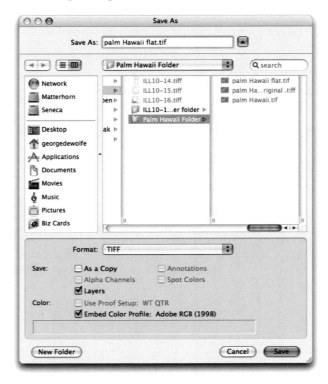

3. In the Layers palette, click the arrow in the upper-right corner and choose Flatten Image. The layers will all combine with the background.

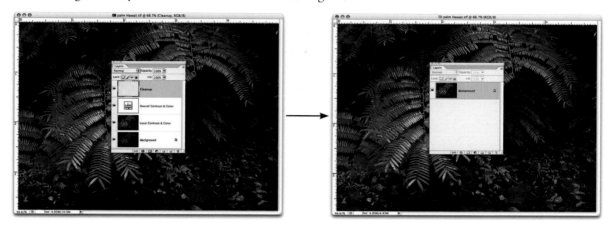

4. Type ⌘-s/CTRL-s to save the image as a flat picture with no layers.

Noise Removal and Sharpening

Techniques for removing noise and sharpening abound. I have tried as many as I can find and have investigated the theories behind them as well. (See *The Image Processing Handbook* by John Russ [CRC Press, 2002], www.drjohnruss.com/.) The techniques all provide about the same end result—the print—but I've found that those that are the simplest and most efficient suit my workflow best. I'm going to demonstrate an interactive way of removing noise and sharpening that uses two layers, one for each function. I'll use Noise Ninja for noise removal and Optipix Safe Sharpen for sharpening, because they are simple, easy, and efficient, and the printed results are excellent. Let me emphasize that you can take many routes to noise removal and sharpening; this is my own method using third-party plug-ins.

I'll consider noise removal first, because if you sharpen noise first, all you get is more noise. If noise is removed first, sharpening affects what remains—hopefully the detail and edges of the image. Noise is an artifact left over from several different exposure problems, especially long exposure times and high ISOs above 400. Sometimes it occurs mostly in the blue channel of RGB images. Sometimes it doesn't occur at all, at least for practical printing reasons.

Let's take an easy example first: If an image doesn't have any noise, it doesn't need to be removed, and you can proceed to sharpening immediately. In this case, all that is needed is to apply Optipix Safe Sharpen or some other sharpening tool, and the job is done, as shown by the following images. This may apply to more than half of the photographs you take.

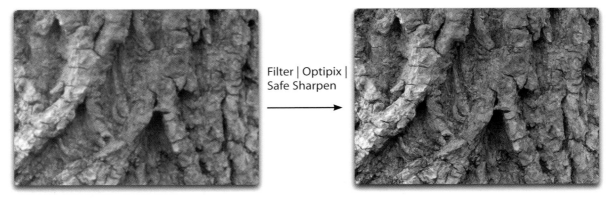

Filter | Optipix | Safe Sharpen

Let's look at a photograph that needs *both* noise removal and sharpening.

The very noisy photograph at right was taken at an extremely long exposure before I learned to turn on the noise reduction feature in the camera.

Here's how I'll fix this image:

1. I set up two layers on the image: one for noise reduction and the other for sharpening. I drag the Background layer to the New Layer icon at the bottom of the Layers palette twice and name the new layers Noise and Sharpen.

New Layer

192

Double-clicking the Zoom tool brings the picture to 100 percent, or Actual Pixels, so I can see the noise really well. Sometimes the image needs to be enlarged to as much as 400 percent to see the noise.

2. On the Noise layer, I run Noise Ninja by choosing Filter | Picture Code | Noise Ninja. Noise Ninja could be used in much more sophisticated ways than the way I use it. You can locally paint noise removal and use masks, but I just use Noise Ninja's simple noise removing technique. In the Noise Ninja window, I position the yellow square within the picture in an area that covers most of where the noise exists. In this picture, the noise is everywhere.

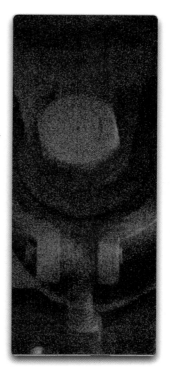

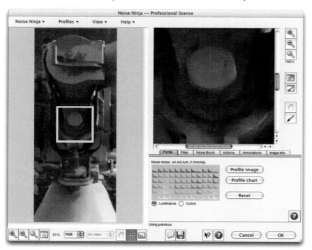

3. I choose the Luminance button and then click Profile Image. The noise in the photograph shows up as small squares in the preview window. I then click OK at the bottom of the Noise Ninja window.

Most of the noise is removed, leaving a slightly blurred image that still retains the detail. This is a very noisy image, and it is almost impossible to get rid of all the noise without blurring the picture too much. (I chose it largely because I wanted to show what happens to the noise visually.)

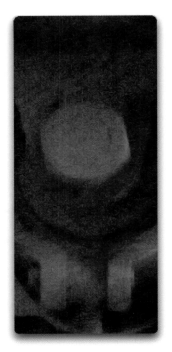

4. In the Sharpen layer, I choose Filter | Optipix | Safe Sharpen. The image sharpens.

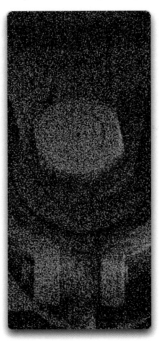

5. I adjust the Opacity setting on both the Noise and Sharpen layers to get the desired noise removal to sharpening effect. Here, the Sharpen layer is adjusted to 32 percent Opacity and the Noise layer is left at 100 percent.

6. I flatten the layers and press ⌘-s/CTRL-S to save the image. The following images show the original image (left) and the final image with noise removal and sharpening.

> **Note**
>
> You can do this in several ways with similar results. Sometimes the sharpening is so great in the Sharpen layer that I duplicate the Noise layer after the noise has been removed and sharpen it instead. All the procedures can be performed on a single layer using the Fade command to reduce the effects. You can also create an action to set up the layers and perform the initial noise reduction and sharpening, and then adjust the Opacity settings manually to get the desired look. Finally, the History Brush 102 technique (explained in Chapter 9) can be used with a snapshot to paint sharpness and blur onto local areas of the image.

Interpolation

With digital SLR cameras carrying 12 to 16 megapixels, 16-bit RAW files, and a 13-by-19-inch printer like the Epson Stylus Photo R2400, you usually have no reason to interpolate (enlarge) an image. With the D2X, Nikon's latest 12.2 megapixel achievement, and the adjustments for normal resolution in Adobe Camera Raw, my default image size is larger than 11-by-17 inches.

Adobe Camera Raw size and resolution

Photoshop Image Size window

At the largest interpolated size in Adobe Camera Raw (4081×6144 pixels at 240 pixels/inch), it's a whopping 17-by-25 inches, big enough to print on the Epson Stylus Pro 7800, a 24-inch-wide inkjet.

Needless to say, unless the size of the print is very large—say more than two times the size of the original RAW file—interpolation is unnecessary, and unwanted. We don't want to add more data that doesn't really belong to the original image, even though "they" say it's visually lossless. But if a big print is to be made, we *have* to settle for less quality, to my visually heightened sense, even though we really can't see the less that is lost. This was true in traditional photography when an enlargement was made, and it's true in the digital world, and the laws of physics don't change. So, to make a long story short, I've tried all the interpolation software available and found them all wanting, except for Fred Miranda's SI Pro 2 (www.fredmiranda.com), which clears the bar comfortably.

A few years ago, Chris Russ of Reindeer Graphics and I sought to improve on the various interpolation plug-ins by making one for Optipix. Chris wanted to get rid of edge fuzziness (called *empty magnification*), or definition, common in all interpolation schemes. What we notice as photographers and printers is the edge of the sharpening, and interpolation destroys this edge sharpness. The result of this long investigation and testing resulted in Interactive Interpolation, and this is the method I now prefer to use when I have to interpolate. Here's how it works:

1. Open an image in Photoshop that has been through the workflow, has been sharpened, and has had the noise removed. Choose Filter | Optipix | Setup 2nd Image. (In some cases it may be necessary to choose Filter | Optipix | Clear Buffer to get rid of any images that may be stored from previous operations.)

2. Choose Image | Image Size. In the Image Size window, change the Width and Height to the enlargement desired. Leave Scale Styles, Constrain Proportions, and Resample Image checked. Choose Bicubic as the resampling algorithm.

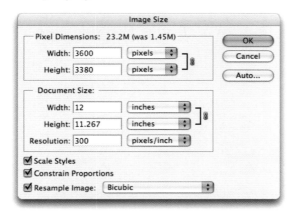

3. Choose Filter | Optipix | Interactive Interpolation. Adjust the sliders until the preview looks good. The Sharpness slider controls the sensitivity of interpolation of detail. It ranges from a very fuzzy detail result to a very sharp detail result. The Edge Strength slider allows you to add back in some of the edge definition lost to the fuzziness caused by interpolation—it finds the edges and gives them a boost. The Grain slider adds grain to break up a sometimes nasty posterization effect. Adding grain makes the edges look natural, as grain *texturizes* the edge. The greater the enlargement, the more grain texture you need. When you are satisfied with the results, click OK.

4. Wait for the progress bar to finish and save the image by pressing ⌘-S/CTRL-S.

Photoshop Bicubic Interpolation

Optipix Interactive Interpolation

> **Note**
>
> If you find that the image still needs to be sharpened more, apply one more round of Safe Sharpen to the image and choose Image | Fade | Safe Sharpen. Pull back on the Opacity slider to reduce the sharpening effect.

Edge Burning

Edge burning, one of the aesthetic adjustments we made in the traditional darkroom, still has validity in the digital lightroom. Edge burning darkens the edges of the print so that it holds together visually and separates the image solidly from the surrounding white paper surface. The process is similar to balancing, discussed in Chapter 6, but the intent here is to darken the edges slightly for image coherence rather than balance.

Edge burning can be accomplished by choosing Filter | Distort | Lens Correction, but I find this filter, though easy and simple to use, does not do precisely what I want it to as far as edge burning is concerned.

I need a stronger gradient at the edges and a less apparent one toward the middle of the picture than Lens Correction gives me. I invented a technique some years ago, using Gradient adjustment layers in the Layers

palette, Soft Light mode, and the Opacity setting, to make an edge burn on my photographs. I set this up as an action, with an F1 key to initiate it, so that it becomes a one-button technique.

Here's how the Edge Burn action is set up:

1. Open an image that needs edge burning and bring the Actions and Layers palettes onto the desktop. '

2. Create a new action set by clicking the arrow at the upper-right corner of the Actions palette and choosing New Set. In the New Set dialog box, name the new set Edge Burn Folder. Click OK. The Edge Burn Folder set will appear in the Actions palette. (Both a new action and a new action set can also be created using icons at the bottom of the Actions palette.)

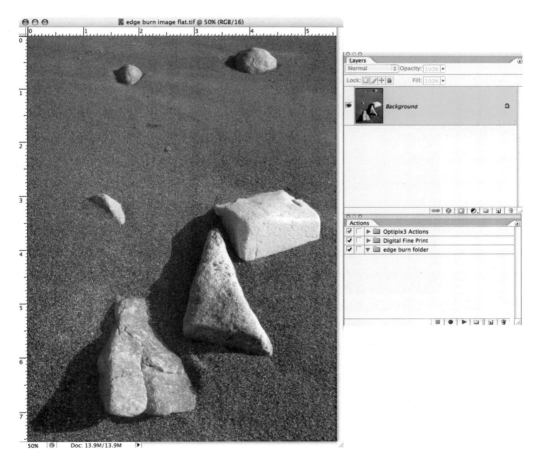

3. Create a new action by clicking the arrow at the upper-right of the Actions palette and choosing New Action. In the New Action window, type the following:
Name: Edge Burn
Set: Edge Burn Folder
Function key: Choose a function key. I use F1. (Note to Windows users: Because of the Help system function of the F1 key, you'll have to make another choice.)
Shift: Select this checkbox.

4. Click Record. The Action will now be recorded.

5. Click and hold the Create New Fill or Adjustment Layer icon at the bottom of the Layers palette and choose Gradient. Press D on the keyboard to set the foreground and background default colors.

6. In the Gradient Fill window, set the following:
Gradient: Foreground to Transparent (black on the right with a checkerboard on the other end)
Style: Reflected
Angle: 90
Scale: 150
Reverse: Checked (when you click Reverse the black and checkerboard will switch)
Dither: Checked
Align with layer: Checked
Click OK.

7. In the Layers palette, select the Background layer.

8. Repeat steps 5 and 6. In the Gradient Fill window, use the same settings as described in step 6, except for Angle—set Angle to 0 instead of 90. Click OK.

9. Select both Gradient Fill layers by SHIFT-clicking, and then click the arrow in the upper-right corner of the Layers palette and choose Merge Layers. The layers will now merge into one.

10. For the remaining Gradient Fill layer, choose Soft Light for the Mode.

11. At the bottom of the Actions palette, click the Stop icon to stop recording and end the action. The new Edge Burn action is created and appears in the Actions palette.

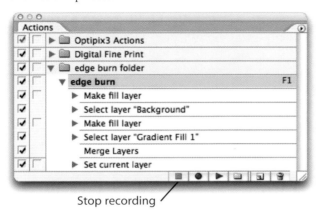

Stop recording

12. To try the action, open an image that needs to be edge burned, press the SHIFT-*function key* combination you chose for your action, and watch. Adjust the Opacity setting in the Layers palette to get the desired effect—usually a very low number is good. What is wanted is just a hint of darkening around the edges. Flatten and save.

The following images show before (left) and after (right) the Edge Burn action has been applied (the effect has been exaggerated here).

Final Contrast Tweaks

When I get to this stage of print preparation, I start to take a broad look at the image and, especially, the overall contrast. It's not something that I see, really—it's something I *feel*. If the little intuitive, contrast-sensitive voice inside me has its antennae out, I'll be able to tell how the contrast needs to be adjusted slightly. For this purpose, I use an interesting Photoshop tool called the Gradient Map.

First, I make sure that my image is flattened and that foreground and background colors are at their defaults by clicking smaller set of squares on the icon.

Next I choose Image | Adjustments | Gradient Map, and in the Gradient Map window I click OK. The image will turn to black-and-white if it isn't already.

I *immediately* choose Edit | Fade Gradient Map. If the picture is black-and-white, I leave the Mode alone. If the Image is in color, I change the Mode to Luminosity to see the image in color. Then I adjust the Opacity slider until the contrast is just right. I click OK and save.

Converting to 8-bit for Printing

No fanfare yet. This last bit lets you convert the image to 8-bit for printing. It's short and sweet:

1. Choose Image | Mode | 8 Bits/Channel.
2. Choose File | Save As. Save and name this image as a separate file in its folder with the other iterations of the picture.

The image is now ready for printing.

11 Print

In this chapter, you will learn how to print black-and-white and color prints using the Epson, QuadTone RIP, and ImagePrint drivers.

For all the messing around we do in Photoshop to prepare an image for printing, there had better be a payoff, and that's why I like to say that the printing process usually comprises clicking one button—Print. If you practice and learn the workflow, most images can be prepared within 15 minutes, even though I've spent a whole book explaining how to do it. At this point, it might be well to remember that our goal is excellence and consistency, the hallmarks of the workflow for the Digital Fine Print Workshop.

Here are some things to check before printing:

- Color settings in Photoshop (just look quickly; refer to Appendix B)
- Correct profile for the printer and paper (see Appendix A)
- Photograph is in 8-bit RGB or grayscale and flattened
- Printer is turned on and paper is in the feeder
- Printer is connected *directly* to the computer (often overlooked and frequently aggravating)
- Ink levels in the printer are adequate and nozzle is clean (just to make sure that baby is running right—see the printer owner's manual for this information as every printer is different)
- Coffee or favorite beverage at a discreet distance (but still within arm's reach) from the working space

On each print I make, I actually perform the Epson, ImagePrint, or QuadTone RIP workflows that I discuss here.

> **Note**
>
> Digital technology changes daily, and to keep up with it is an ongoing task. This includes rapid developments in inkjet printing technology, inks, paper, and ideas. My mission for most of the workshops I teach throughout the United States is to foster simplicity in choices that leads to excellence and consistency in the final print. Any of the Epson printers, and some of those of other manufacturers, produce excellent and consistent results, but I favor Epson because I think it is the best. This is an opinion, but a very thoughtful and practiced one. The workflows for the printers covered in this chapter are those that I use today (March 2006), but these will no doubt change in the near future. Future editions of this book will include my latest choices.

Printing with the Epson Stylus Photo R2400

The Epson Stylus Photo R2400 (and its bigger brothers and sisters, the Epson Stylus Pro 4800, 7800, and 9600) is the best photo inkjet printer this company (or any other company, for that matter) has ever produced. It uses eight permanent pigment inks, called UltraChrome K3 ink technology, that sport from 85- to 200-year fade resistance, depending on the type of paper. It has a greatly enhanced color gamut from the old UltraChrome inksets on its predecessor, the Epson Stylus Photo 2200, and it prints black-and-white images flawlessly and with complete neutrality. The Epson website (www.epson.com) has complete technical details and specifications. I highlight this printer because it is the best there is (as of March 2006) in its size range (13 by 19), and a majority of serious photographers use it. Its bigger brothers and sisters have exactly the same inksets, so printing with one of them is like printing with another, with the exception of size and cost. At least for the foreseeable future, it's not which printer to buy, but which *Epson* printer to buy.

Black-and-White Printing with the R2400 Epson Driver

For the first time in history, we are fortunate to witness high-quality OEM (original equipment manufacturer)-generated, native black-and-white printing with the Epson Stylus Photo R2400. The results are absolutely neutral, with no color shifting in the highlights, shadows, or midtones. If you were in on this technology at the very beginning (10 years ago), you'll realize how far printers, inks, and papers have come in reproducing very high-quality black-and-white photographs. It is even more amazing, if you've been around the printing industry as long as I have, to see a magnificently printed black-and-white photograph from colored inks. This has been the Holy Grail of printing since color inks were invented.

In addition to a new black-and-white ink, Light-Light Black, black-and-white images also use the Matte (or Photo) Black and Light Black inks to print. Epson has also introduced a new Advanced B&W Photo mode to control black-and-white printing. In this section, I'll show a neutral black-and-white workflow using this printer and how the special black-and-white controls work to improve the image. First the workflow.

Although any image, RGB and grayscale, can be printed using this method, I suggest using either an RGB image in which the colors have been desaturated or a grayscale image proper. My workflow is for a Macintosh, but the Windows version is similar and is included in the R2400 *User's Guide*.

1. Open an image in Photoshop. The photograph should be desaturated RGB or grayscale. If the image is Adobe RGB (1998), use the embedded profile. If the image is not in Adobe RGB space, convert to the working space if necessary. If the image is Grayscale, Gamma 2.2, use that embedded profile but convert to the Grayscale, Gamma 2.2 working space if necessary. Edit if necessary.

2. Choose File | Page Setup. In the Page Setup dialog box, select Stylus Photo R2400 from the Format For drop-down list. Choose a paper size from the Paper Size drop-down. This is a little tricky, as the paper size name chosen will depend on what media type you are printing and which of the two paper feeders you're using. The user's manual doesn't specify this, so you'll have to experiment. Set the Orientation and click OK.

3. Choose File | Print. In the Print dialog box, choose Stylus Photo R2400 from the Printer drop-down menu.

4. In the drop-down list below Presets, choose Print Settings. The Print dialog box will change to include more settings. Select the appropriate Media Type, and choose Advanced B&W Photo from the Color drop-down. For Mode, check Advanced, and for Print Quality, choose Best Photo. Uncheck High Speed.

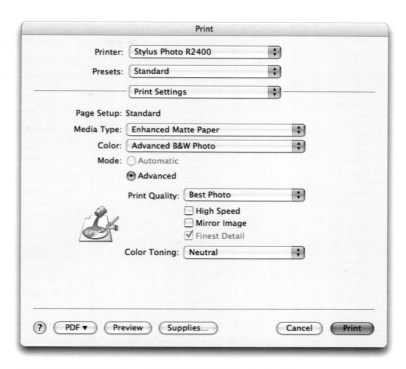

5. Return to the drop-down below Presets and change it from Print Settings to Color Management.

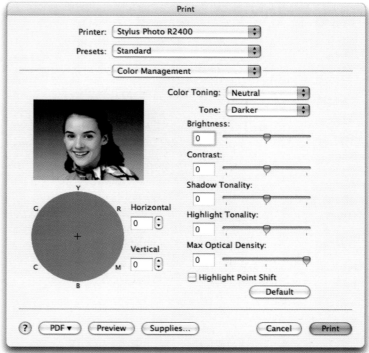

6. Do not change any of the sliders for the first print. Just click Print. When the image prints, and you've followed the workflow for the Digital Fine Print Workshop so far from camera to Photoshop CS2 to printer, the printed image should be very close to what you see on the monitor. Make sure you view it under a standard light source such as the GTI PDV2D Personal Desktop Viewer.

7. Scrutinize the picture using the qualities of the digital fine print as your guide, checking cropping, contrast, brightness, defects, and sharpness. Look especially at the detail in the highlights and shadows and see if the midtone gray separation is what you like. Look, too, at the print neutrality. If any of these things is amiss in any way, either globally or locally, go back to Photoshop and tweak the image in the direction it needs to go. Try to do without the Epson Advanced B&W Photo mode slider controls, if possible, though they do a pretty good tweaking job for some things in a black-and-white picture. If you need to use them (or just want to) here's what they do:

- The default setting for the Advanced B&W Photo mode uses Color Toning set to Neutral and the Tone set to Darker. The other choices for Tone are Darkest, Dark, Normal, and Light. There is neither rhyme nor reason to this nomenclature. This is what happens if you change them. If Darker (the default setting) is considered a normal exposure, Darkest is a ¼ stop exposure decrease from Darker, Dark is a ¼ stop increase from Darker, Normal is a ⅓ stop increase from Darker, and Light is a ½ stop increase from Darker.

> **Note**
>
> These changes are difficult to show in the book, which is why there are no pictures with these descriptions.

- The Brightness slider controls overall brightness and varies about –2 ½ stops toward the left position to +2 ½ stops on the right position.
- The Contrast slider at –25 decreases the overall contrast of the image from middle gray toward both ends by about 1 ⅓ stops, and the +25 setting increases overall contrast from middle gray toward both ends about 1 ⅓ stops. The effect of lowering contrast is similar to decreasing (–25) the midtone contrast overall, and of raising contrast to increasing (+25) the midtone contrast overall.

- The Shadow Tonality slider is extremely subtle. At −25, I could see only a slight increase in contrast in the shadows from the +25 setting. (It took me three times to convince myself, through a double-blind test, that there was any difference at all.) You might consider this slider at −25 a "seating the blacks" sort of trick.

- The Highlight Tonality slider shows much greater differences. At −25, there is a ¼ stop decrease in contrast in the highlights only, and the +25 setting shows a whopping 1 stop increase in contrast in the highlights only.

- Max Optical Density basically gives you a "high-key" image at −50, with the darkest shadows turning to neutral gray and then graduating into white.

- Highlight Point Shift covers the whole image (including the white surface of the paper) with a 2 percent value similar to what we used to call "flashing" in the traditional darkroom. The highest white values are affected the most.

Color Printing with the R2400 Epson Driver

Here is the method for printing color images. Again, my workflow is for a Macintosh, but the Windows version is similar and is included in the R2400 *User's Guide*.

1. Open an image in Photoshop. The photograph should be embedded with the Adobe RGB (1998) profile if you've been following the workflow. If the image is not in that profile, convert to the Adobe RGB (1998) in Photoshop CS2 Color Settings if necessary. If you prefer to leave an image in the embedded profile and it is not Adobe RGB (1998), you can open it in Photoshop, choose Edit | Assign Profile, and select Adobe RGB (1998).

2. Choose File | Print With Preview.

3. In the Print dialog box, choose Color Management from the drop-down below the preview window, and then select the following settings:

 Print: Document (Profile: Adobe RGB (1998))

 Color Handling: Let Photoshop Determine Colors

 Printer Profile: Select the printer profile for your paper—in the example shown on the following page, it is set at Epson Enhanced Matte with Matte Black Ink (MK).

Rendering Intent: Relative Colorimetric with Black Point Compensation checked. If the profile was created with Perceptual Rendering Intent or the image has extremely saturated colors, use Perceptual.

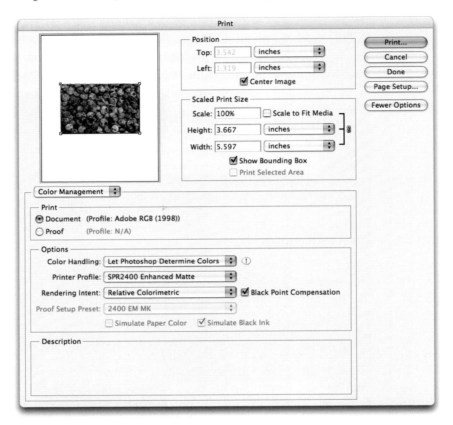

4. Click Page Setup.
5. In the Page Setup dialog box, use the following settings:

 Format for: Stylus Photo R2400

 Paper Size: US Letter, or choose the size you are printing on. The many choices here depend upon the paper and paper tray you are using.

 Orientation: Portrait (vertical, first icon) or Landscape (horizontal, second and third icons).

 Scale: 100%
6. Click OK.

7. Back in the Print with preview dialog box, click Print.

8. In the Print dialog box, choose the following settings:

Printer: Stylus Photo R2400

Presets: Standard

Print Settings (choose from the drop-down just below Presets)

Media Type: Enhanced Matte Paper (or the paper you are using)

Color: Color

Mode: Advanced

Print Quality: Best Photo

High Speed: Unchecked

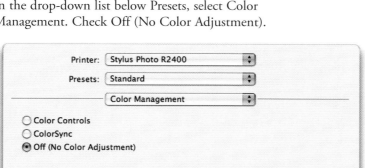

9. In the drop-down list below Presets, select Color Management. Check Off (No Color Adjustment).

10. Click Print.

11. Compare the print with the monitor under the viewing light. Evaluate the qualities of a digital fine print: cropping, contrast, brightness, color, defects, and sharpness. Look especially at the detail in the highlights and shadows and see if the midtone separation is what you like. Look at the print color carefully. Evaluate whether the print is too light, too dark, or too contrasty. A small difference in any of these can make the difference between a good print and an excellent one, or between an excellent print and a masterpiece. If any of these things is amiss in any way, either globally or locally, go back to the image in Photoshop and tweak it in the direction it needs to go. Make another print and compare.

If the workflow is carefully followed, the print should need little or no work, but be prepared to make as many as 5 to 10 prints before you are satisfied. Have the print sit on a wall for a day or two and let it "speak" to you. This allows reflection and observation to assist you in getting the best print you can make of the photograph (at least today!). (If I really get nervous and picky about prints being made for exhibition, I'll frequently cut an overmat to see what the picture is going to look like when it's on the wall.)

Printing with the ColorByte ImagePrint RIP

As is understandable in the business world, Epson America and Seiko/Epson in Japan are protective of their printers, inks, and papers. And, as a privately held company (in Japan), they are not at the bidding of stockholders. But they do listen, sometimes more than any other company I've dealt with, to the needs of the photographic community. As a result, Epson makes the best inkjet printers in the world for fine-art printing.

For many years, third-party companies have produced inks and papers to fit Epson printers, and these have sometimes been better than the Epson inks and media. The most notable examples are the color gamuts of the Lyson and MediaStreet Generations inksets and the incredible power of Jon Cone's Piezography in black-and-white quadtone printing. With the introduction of the Epson Ultrachrome K3 inkset in the R2400, 4800, 7800, and 9800, wide color gamut is no longer an issue. Epson has made deep inroads, also, in black-and-white printing with color inks. With the new Advanced B&W Photo mode, there is complete neutrality and high quality. What remains is media.

Paper is an intimate and personal choice. No two people agree on what is best. And it is for this reason, along with the excellent quality and consistency (remember these?), that the ColorByte ImagePrint RIP comes into play. Basically, this is a printer driver of extremely high quality and precision. The profiles that go with it, for just about any media you can think of, are second to none. And the black-and-white printing lays down a quality on selected papers that has depth and substance. If you compare a black-and-white print made on Hahnemühle William Turner and one with Epson Enhanced Matte, there is no contest. Turner simply has

three-dimensional depth and shadow detail unseen even in the traditional darkroom. Granted, Epson's Velvet Fine Art produces a superior print to the Enhanced Matte also, but there are always going to be those finicky and exacting photographers (like me) who want the last ounce of quality, and they will often choose a paper not made by the manufacturer of the printer to get that quality.

ImagePrint allows us to print on any media we want, on any of the Epson printers, as long as ColorByte makes a profile for that paper. Suppose, for a minute, that we return to the traditional darkroom. Kodak makes Dektol, a paper developer that many photographers use to produce prints. Kodak also sells paper, and of course they'd be happy if we all went out and bought Kodak Elite to print our photographs (but this is a moot point, as Kodak has announced it will quit making photographic paper). Some use the manufacturer's papers, yet others (like me) think Ilford Galerie, for instance, has an edge on quality, and they might want to develop Ilford Galerie in Kodak Dektol (diluted 1:3) and claim that to be a superior workflow (if I may). This is precisely the case with inkjet media. *If the paper is of high quality to begin with, and it has been tested by the paper manufacturer with the particular inks and printers you are using, and there are profiles made for that paper and ink,* then it's okay to print with other media that you like. Epson has indeed been gracious in allowing, and to a certain extent fostering, the media of other companies and the software RIPs available to allow photographers the choices we want to make.

Using ImagePrint is simple. Setting it up takes a little time and patience, and I always recommend that you print and read the instruction manual thoroughly, because it contains everything you need to know and answers every question. The bad news is that it's 200-plus pages long. The good news is that it's printed in very large type and has lots of pictures.

Here's the basic workflow for both black-and-white and color printing: it's for the Mac here, but the Windows version is similar.

Along with the other printer checks discussed in the first part of this chapter, make sure the dongle for the ImagePrint is plugged into a USB port on your computer.

213

1. Open ImagePrint and drag a photograph onto the ImagePrint window. If a dialog box appears asking you to use the embedded profile, click Yes.

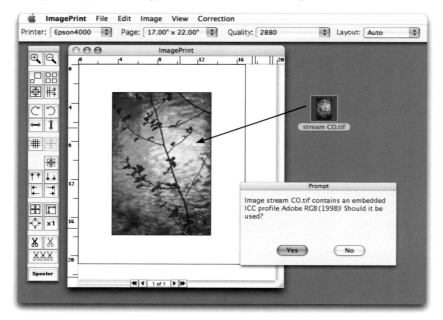

2. Choose Image | Color Management. In the Color Management window, choose the Output tab. From the Printer/Paper drop-down, choose a color profile for a color image, and for a black-and-white image, choose a black-and-white profile (it will have the word *gray* in it).

3. Click the Bitmap tab and use these settings:

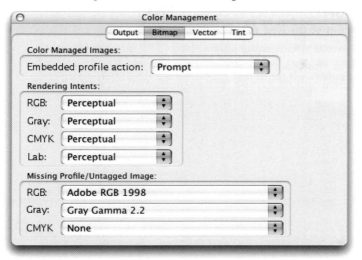

4. Close the Color Management window.

5. Choose File | Print. When the Print Dialog window appears, click Setup and make sure the settings in the Printer Setup dialog box are correct for a black-and-white (see image below, left) or color image (below, right). Click OK to exit Printer Setup.

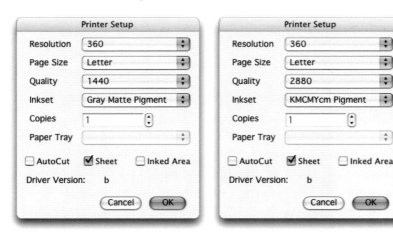

6. Click OK in the Print Dialog window and immediately open the Spooler by clicking the word *Spooler* at the bottom of the ImagePrint Toolbox (shown at right).

7. Check to see that the correct printer is initiated.

Check that the Queue is Enabled and look at the bottom left of the Spooler window to see that the printer is enabled and printing. You'll hear a click from the printer and it will start printing.

8. Evaluate as usual, tweak, and print again if necessary.

Printing with the QuadTone RIP

The QuadTone RIP (www.quadtonerip.com), invented by Roy Harrington, allows us to print on any media we want, on most of the Epson printers, as long as a profile exists for that paper. Using the QuadTone RIP is simple. Setting it up takes a little time and patience, and I always recommend that people print and read the instruction manual thoroughly, because it contains everything you need to know and answers every question. I use the QuadTone RIP in conjunction with the Cone K7 Piezography inks or the MediaStreet Quadtone inkset. I recommend the MediaStreet to people on limited budgets because the company offers a solution with the QuadTone RIP on a very inexpensive Epson 8 ½-by-11 printer. I use the Cone Piezography K7 inks on the Epson 2200 and the 4000.

Following is the basic black-and-white workflow for the Cone Piezography K7 inks and the QuadTone RIP on the Epson 2200, but the interface will be the same for other printers. This procedure is for the Mac, but the Windows version is similar.

1. In Photoshop, choose File | Page Setup. In the Page Setup dialog box, set the Format For drop-down to Quad2200-NK7, and set your Paper Size and Orientation. Click OK.

2. Choose File | Print. In the Copies & Pages drop-down menu, choose QuadTone RIP.

3. Set Mode to QuadTone RIP and Feed to whatever method your printer is using—Sheet Feed, Manual Feed, or Roll Feed. Set Curve 1 and Curve 2 to the printer profile for the paper you are printing on (in this case Hahnemühle Photo Rag at 2880 dpi), Resolution at 2880 (or the dpi of the profile), and High Speed as Faster or Better.

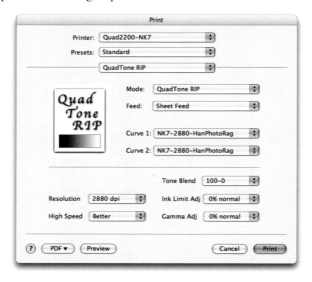

4. Click Print.

The Highest Quality Print

The question I get most frequently in workshops is "When do I quit?" I have always looked upon a final print of high quality as a work of art. As a result, I am always striving for the best I can do, and I don't give an inch when it comes to technical excellence. But the print has another dimension that I call *presence*. It has almost nothing to do with the technical side, but it is a matter of craft, that careful blend of aesthetic judgment and technical skill. Presence in a print has a way of suspending time so that you feel as though you are part of the print rather than apart from it. It is a true virtual reality in which you become suspended in another world. The feeling of the presence may last for a few minutes, or, in the case of a masterpiece, a lifetime. In the end, the feeling of presence is that the picture is complete and whole in every way, the visual, the intuitive, and craft have become one, and a stillness in your being reigns. This is the point where you need to stop. The conductor, the orchestra, the performance, and the audience are one.

PART III
APPENDIXES

What You Need

"What do I need to set up a lightroom?"

During the course of workshops, telephone conversations, and e-mail, this question, or some derivation of it, is the most common I receive and answer. And I can offer suggestions about what I think is the best, because I've tried almost everything and have spent a lot of money in the process. What I'll provide here is a very informed opinion.

It may be apparent, even to the most devoted digital enthusiast, that a setup used by a professional and one used by an amateur may differ. In this appendix, I try to address lightroom setups for serious amateurs, "light" professionals, and those traditional photographers who are entering into the confusing world of digital photography and printing. What varies with serious large format printing for professionals is the size and number (and cost) of printers, cameras, computers, and—oh yes—don't forget the accessories.

I decided to put this section in the back of the book because it doesn't break the momentum of the workflow and, especially, because the technology changes so fast that rewriting this appendix in one year will undoubtedly alter the content entirely. This is both a blessing and a curse. The fact that digital photography changes at the speed of light discourages many, but photographers are notorious for wanting, needing, and having equipment. My solution to all this has been to keep everything as simple as I can, feed the obsession occasionally, accept the constant change, and just make prints.

Computer and Equipment

Photoshop CS2 works essentially the same on both Macintosh and Windows platforms, but the print interfaces are totally different. I think the way files are stored on a Windows machine is medieval, and managing many photographs can be a nightmare. I use both Windows and Mac in my studio. Windows is a better print server than Mac, but only for complicated RIP software that is mostly written for Windows. I don't recommend any software that is not compatible with both platforms, because I have to teach at workshops all over the country, many of which have both Windows and Mac environments, so I tend to know these machines rather personally.

Regarding the never-ending Mac versus Windows argument, consider this interesting experience I had at the PhotoPlus trade show in New York. I sat on a digital printing panel, at the far end of the table, with a group of some of the best-known experts in digital photography and printing. I left my seat on the dais to get some water, and I stood for a few moments, looking at the panel of experts from the audience's perspective. What I saw was a row of laptops with a little apple shining in the center of the upraised cover of each expert's computer. What a statement.

I can run the most sophisticated Epson printer from an Apple 12-inch PowerBook. However, the PowerBook may not have enough power and speed to work with very large digital files from a professional 12+ megapixel digital single lens reflex (DSLR), and it can take too long waiting for Bridge to process the RAW files. The screen also has a small color gamut that makes color management difficult. The small laptop's screen can be calibrated—although it works, it's slow. The same goes for a small Windows laptop, but its power and speed is even worse. A powerful laptop, such as the 17-inch PowerBook (or the new Intel MacBook), would probably do the job, but I find that a medium-priced desktop, such as the iMac G5 (or Intel model) with the 20-inch screen (or the equivalent in a Windows environment), a 250GB hard drive, and 2GB of RAM really does the trick. Make sure you also get the fastest CD/DVD burner you can find. These are the *minimum* requirements I recommend for digital photography.

> **Note**
>
> If you have a tower computer that has PCI slots for expansion cards, unless there are other needs, I suggest filling these with FireWire/USB PCI (or PCI Express) cards. FireWire and USB hubs are not as reliable as their PCI connection equivalents, so I use PCI slots instead for connecting my peripheral devices.

You should also consider one or two extra external hard drives (from 200GB to 1 terabyte). You'll need them for storing all your photographs. LaCie and SmartDisk make reliable and portable drives that I like, but for many thousands of RAW files, you'll probably need a RAID array. A FireWire hard drive is much faster than a USB version.

You'll need plenty of CD/DVD media for backing up all your images. Delkin gold media—both CD and DVD—is rated to archival standards and supplies the current standard.

Working Environment

You must be physically comfortable. This *is* the main consideration when working for hours at a computer/printer workstation. Other factors, such as subdued ambient light and neutral walls, are helpful as well, but these are often not possible, especially for those who have no dedicated workstation/space. However, you can get away with fairly subdued ambient light and a print viewing light with the correct color temperature (I like the GTI Lite PDV-2D and 3D with the rheostat). My comfortable chair cost $99 at a office supply store; I bought it after sitting in all the display models there. The chair I covet, however, is the Aeron chair, at $900 as of this writing, that looks like the ejection seat in a Navy F-18 Hornet.

People have different needs for a comfortable workspace. I like everything within arm's reach, especially the coffee, when I'm slaving away at the computer. I like real pencils and a manual sharpener (because it makes the best point), several sticky note pads, and my cell phone nearby. I try to keep things simple, clean, and orderly, but others work in exactly the opposite environment, with equal results. Just make it comfortable for *you*.

Monitor

For now and the near future, the standard lies with the LCD (liquid crystal display) flat-panel monitors. You need to spend the money and get a good monitor; it's like buying a good lens. The best and most affordable ones are Apple's 20-inch, 23-inch, and 30-inch LCD monitors. They can be accurately color corrected and are sharp and clear. Recently, LaCie and Eizo have produced monitors that have a greater bit depth (10-bits, as opposed to 8-bits) and offer very accurate color calibration. These monitors are known as "smart monitors" because calibration is accomplished without human visual intervention. Smart monitors will be the future of this technology as well as other types of viewing interfaces. The only other flat panels that might have an edge are medical monitors used for X-ray and PET scanning, but they are frightfully expensive—at more than $10,000.

Monitor Calibrator

For accurate color *and* black-and-white work, your monitor needs to be calibrated. You do not have a choice about this, unless, of course, you want

me to load the gun for you. For LCD flat panels the MonacoOPTIXXR, GretagMacbeth Eye-One Display 2, and ColorVision Spyder2 are all good choices. Consider for a moment that the GretagMacbeth Eye-One Photo, expensive though this item may be, makes printer profiles very, very well—and quickly I might add—along with giving a very accurate monitor calibration on an LCD. If you just want a monitor calibrator, and plan to get your printer profiles by other means, the preceding three devices are all excellent choices. If you have a smart monitor, you need to get the calibrator tool and software that is sold for it. All monitor calibrators have easy-to-use wizard software that walks you through the steps of calibration. Always buy the "pro" model where it is available.

Printer

I'm not going to draw this one out. At this point, Epson printers are the best; you just have to figure out which one to purchase. The 2400 (13 inches wide) and the 4800 (17 inches wide) are going to be the standards for most advanced amateurs and light professionals, and unless you need prints larger than 17 inches wide, there is no reason to consider anything else. The 7800 and 9800 are for those of you who need the big ones—24 and 44 inches, respectively. All these Epson printers use the same Epson UltraChrome K3 inks. If you need a good RIP (raster image processor or printer driver) to print with other manufacturers' papers, such as Hahnemühle, especially black-and-white images, the ColorByte ImagePrint RIP is the best and least expensive for both Mac and PC platforms.

Printer Setup

Here's my mental checklist for setting up your printer (closely following the Epson Start Here folder enclosed with each printer):

1. Unpack the printer and check to see that all the parts are included.
2. Set the printer on a nearby accommodating flat surface.
3. Plug in the printer, turn it on, and install the inks and paper.
4. Install the software driver.
5. Connect the printer to the computer (either with FireWire or USB).
6. Set up the printer in the printer utilities window (this varies with Mac and Windows).
7. Open Photoshop and a familiar image using the instructions in the user's manual and print something, for crying out loud.

Papers

I am frequently asked, "What is your favorite fine art inkjet paper?" I usually avoid the obvious by answering, "I use different papers for different purposes," which is true. But on another note, how does one figure out which paper *is* best (a personal choice and opinion)? There is a simple but profound answer: buy a box (25–50 sheets, 8.5×11-inch) of the paper in question and print pictures with it. Not grayscales or test charts—real pictures. This is the only way to tell whether a paper is going to be "the best." If you rely on anyone else's opinion (even mine), you will be disappointed in the extreme.

Back in the dark ages of inkjet printing (1995–97), we basically had one printer and one paper that sufficed to do the job: the Epson Stylus 3000 and Somerset Velvet paper (uncoated). Several third-party inks such as Lyson and MIS had better qualities than the Epson inks, and most of us engaged in the fledgling inkjet technology tried them all. Around 1998, changes started happening. Epson (and others) improved the ink sets, coated inkjet paper entered the market—I think the first was Somerset Velvet Enhanced—and the quality improved tremendously. In 1999, Jon Cone came out with Piezography and put black-and-white inkjet printing on a par with traditional darkroom silver prints. In 2002, critical mass was reached and fine art inkjet printing (as well as digital photography in general) took off like a rocket worldwide. Epson raised the bar in 2003 with the introduction of the Stylus Photo 2200 and UltraChrome inks to bring us digital fine print excellence and longevity. Now we have quality in color and black and white that is better and more archival than traditional photography. We have hundreds of great inkjet papers from which to choose.

But I do have my favorites, of course. My paper choices in recent years have been Epson (Enhanced Matte, Velvet Fine Art, Somerset Velvet for Epson for matte choices; Premium Luster for glossy) and Hahnemühle (William Turner, Photo Rag, and German Etching—all matte). I use Enhanced Matte as a standard paper for testing and checking color but not for exhibition. It's relatively inexpensive, so I can use it with reckless abandon in full size to see what's going on in the picture. I rarely make

a glossy print, but when I do it's always with the Epson Premium Luster paper. My exhibition prints are made on Hahnemühle William Turner, Photo Rag, and Epson Velvet Fine Art for excellent color rendition, and Epson Somerset Velvet for Epson if I'm printing very large images on the Epson Stylus Pro 7800 printer. William Turner is especially beautiful for black and white because it adds a certain depth that other papers don't provide.

Understand that these choices are all personal and reflect great scrutiny during evaluation. I find that inkjet papers fall into two categories: the best, and everybody else. Royal Renaissance, from MediaStreet, comes highly recommended from several of my fine art printer friends who have used it.

Note

Regarding paper permanence and archival questions, for complete archival information on a number of papers and printers, including the Epson R2400, visit the Wilhelm Imaging Research website, www.wilhelm-research.com. Henry Wilhelm specializes in permanence testing of inkjet papers.

Printer/Paper Profiles

For every printer/ink/paper combination there exists a specific profile. Or one has to be downloaded, purchased, or made. *Accurate prints cannot be made without a profile.* Whenever a wrong profile is used and the printed result looks funny, different, or weird, you will remember that previous sentence. If no profile exists for the printer/ink/paper combination, one has to be made—no ifs, ands, or buts.

A *profile* is a table of data that tells the printer how to print the photograph we see on the monitor. It tells the printer such things as the color space the picture is in and the grayscale values (important for both accurate color and black-and-white printing). The information in the table is printer/ink/paper specific. No two profiles are alike. If you double-click a profile, it looks similar to Figure A-1.

The .icc tag (see the title bar in the figure) stands for International Color Consortium, the august body that creates the standards for these useful things.

Figure A-1: A look at Epson's Premium Luster profile information

Profiles can be obtained in a number of ways:

- **Printer software** Most printers come with a number of profiles that match the papers produced by that company. For example, the Epson R2400 comes with profiles for popular Epson media (paper) that load with the driver when it is installed. These profiles are generic and generally work fine, but there are better choices.

- **Paper and printer manufacturer websites** Most printer and all paper manufacturer websites, such as Epson, Hahnemühle, Legion Paper, and MediaStreet, offer profiles that are made specifically for fine art printing, and these tend to work much better than the generic profiles shipped with most printers. These are free downloads.

- **Custom ready-made profiles** Several companies, such as www.inkjetmall .com, make profiles for printers that are of very high quality and can be purchased for a reasonable price. At Inkjetmall, a CD of profiles that covers many of the popular papers can be purchased. Free to download (after purchase of the software RIP), the ColorByte ImagePrint profiles are of this type and are some of the best in the industry.

- **Custom-made profiles** Some companies and individuals will make a custom profile for a specific printer/paper/ink combination, and these can be expensive, but the price may be worth it if the job requires it. A chart is printed on the specific printer, paper, and ink and sent to the company for analysis and profile making. Chromix and Inkjetmall make custom profiles. These profiles are usually the best that can be made.
- **Hand-made profiles** Hand-made profiles have the potential of being excellent because they are made on premises with (usually) inexpensive equipment. Profile-making devices for advanced amateurs and light professionals range from MonacoEZcolor to GretagMacbeth Eye-One Photo. Professional profile-making hardware and software cost many thousands of dollars and produce the very best profiles. All of the custom-made profiles mentioned here are made on such equipment.
- **Profile editors** Profile editors are made by several companies and consist of software to tweak already purchased or made profiles. ColorVision makes an inexpensive and useful editor, DoctorPRO, that uses Photoshop Curves and Levels to edit a profile.

You could make profiling your life's work, much like some photographers made Zone System testing theirs. I know some photographers out there will become obsessed with profiling to the extent that no more photographs and prints are made. Get a good profile and be done with it. It's a tool, and a necessary one. Take this stuff seriously, but leave it at the computer when you're printing and at the front door on your way out to photograph. "Take it easy, but take it," as Woody Guthrie used to say.

Digital Camera

For serious work, you need a DSLR camera. I have used Nikon cameras since 1964. I now have a D2X and am completely happy with it. No one can give me a good reason (there are lots of reasons, but no good ones) to change brands. So when you ask me which camera to buy, Nikon is the only one I know well, so I recommend it. But I also know and, more importantly, see, that Canon, Olympus, and Pentax cameras make great images. Choose a brand and stay with it. If you keep switching, you're in for an interminable hell of always wondering whether the grass is greener. (Of course it always is, but it still needs to be mowed.)

Drawing Tablet

I now consider the Wacom Tablet a necessity for editing digital images in Photoshop. It makes burning and dodging incredibly easier than using a mouse, especially when the pen is set up in the Wacom preferences (included with the tablet) to make the brush size larger or smaller and set the pressure-sensitive tip to change opacity by pen pressure. (In the Brushes palette, double-click Other Dynamics and set Opacity Jitter Control to Pen Pressure.) The 6×8 model is what I recommend for photographers, but the 4×5 model is great for traveling.

Print Viewer

For a long time I did not consider a print viewer a necessity for creating excellent prints. One day I bought one, and it was one of the best investments in print quality I've ever made. Looking at a print under the print viewer and comparing it to the on-screen image allows that extra leap in quality we all look for in a print, and I wouldn't be without one now. I use the GTI viewer—the PDV-2D and PDV-3D with the rheostat—and am totally satisfied.

Card Reader

Using a card reader is a far superior, and faster, method of transferring digital images from a Compact (or other format) Flash card to the computer. These items are not expensive, but do get a FireWire-enabled one by SanDisk or Lexar. Rob Galbraith Digital Photography Insights (www.robgalbraith.com) has excellent information on these readers, as well as a Compact Flash database for the fastest flash cards available for your particular model of DSLR.

Software

On the software side, I prefer to be simple, because I don't like upgrading every time I turn on my computer. Of course, you need Photoshop CS2. I also use the Photoshop plug-ins Optipix, iCorrect EditLab Pro, Noise Ninja, nik Sharpener Pro, and Fred Miranda's SI Pro2 stair-step interpolation.

Note

The addition of Adobe Lightroom software, when it is released as a retail version, will undoubtedly affect the entire workshop workflow. I worked on the development, alpha, and beta teams for this software and have only the highest admiration for how it can streamline digital fine printing. I will add Adobe Lightroom to upcoming editions of this book and comment on its workflow on my website, www.georgedewolfe.com.

Resource Links

Here are links to some of my favorite photography and inkjet printing companies. Although the list is not exhaustive, it provides you with a good place to start looking for tools and information, and gives you access to informed opinions on a number of inkjet printing topics (as well as any number of excuses to spend money).

Optipix	www.reindeergraphics.com
Noise Ninja	www.picturecode.com
Printer RIPS	www.colorbytesoftware.com
	www.quadtonerip.com
iCorrect EditLab Pro	www.picto.com
SI Pro2 stair-step interpolation plug-in	www.fredmiranda.com
nik Sharpener Pro	www.niksoftware.com
Inks, papers, and profiles	www.atlex.com
	www.hahnemuhle.com
	www.inkjetmall.com
	www.inksupply.com
	www.lyson.com
	www.legionpaper.com
	www.mediastreet.com
Compact Flash database	www.robgalbraith.com
Flash memory	www.sandisk.com
	www.lexarmedia.com
Print viewing boxes	www.gtilite.com
Drawing tablets	www.wacom.com

Color management software and hardware	www.gretagmacbeth.com
	www.xritephoto.com
	www.colorvision.com
	www.chromix.com
	www.i1color.com
Printers	www.epson.com
Digital cameras	www.nikonusa.com
Computers	www.apple.com
Computer hardware and accessories	www.lacie.com
Monitors	www.lacie.com
	www.eizo.com
Inkjet permanence research	www.wilhelm-research.com
Inkjet supplies	www.inkjetart.com
	www.lexjet.com
Archival Gold compact discs	www.delkin.com

Setting Up Photoshop

An overlooked but critically important step in making excellent and consistent digital fine prints is setting up the Photoshop CS2 color settings, palettes, and workspace. Without the correct settings and palette arrangements, color management and workflow are cast to the wind.

Color Settings

In Photoshop, choose Edit | Color Settings and change the settings in the Color Settings dialog box as shown in Figure B-1. These settings will work for both color and black-and-white images in all the Epson printer drivers and the Colorbyte ImagePrint software RIP.

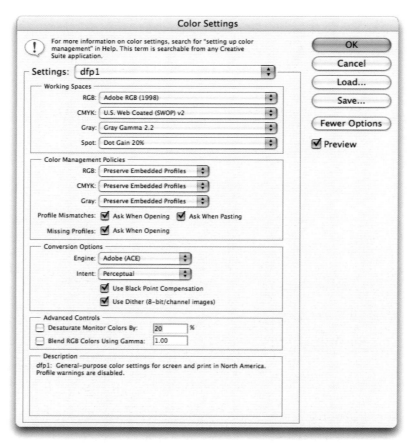

Figure B-1: Photoshop CS2 Color Settings setup for the digital fine print workflow

Palette Settings

One of the many concerns surrounding Photoshop usage is its complexity. Learning this daunting program may take six months, getting comfortable with it can take a year, and mastering it can take a lifetime. I have learned that teaching and practicing Photoshop in the digital fine print workflow requires simplicity. How does one simplify Photoshop? Customizing the workspace allows you to set up the palettes the way you want, and if you choose, to change menu and shortcut preferences. I'll deal only with the palette setup because customizing menus and shortcuts is a personal thing. Customizing makes using Photoshop much simpler, faster, and more convenient.

You need only about half the palettes offered in Photoshop CS2 to produce an excellent digital fine print. Figure B-2 shows the palettes you need: Channels, History, Actions, Histogram, Info, Layers, and Brushes.

Figure B-2: Photoshop CS2 palettes for the Digital Fine Print Workshop

The best and fastest way to create the palette workspace you want is to start from scratch.

1. Delete all the palettes from the palette well and the desktop by closing them (click the upper left button on the palette for Mac, and the upper right "X" for Windows).

2. Choose Window in the Menu bar and click these seven palettes to make them appear on the desktop: Actions, Brushes, Channels, Histogram, History, Info, and Layers. Some of these palettes may be combined with others. If so, click the palette name tab you want and drag it to another place on the desktop. If you end up with some palettes that aren't mentioned above (such as Paths and Navigator), close them. In the end, you should have seven separate palettes on the desktop.

3. Put the Channels, History, Histogram, and Layers palettes into the palette well by clicking and dragging the palette name tabs. Three palettes should remain: Info, Brushes, and Actions. These three need to be set up properly to work simply and in the manner best suited for digital fine printing.

The Info Palette

For digital fine printing, you need only two working spaces: RGB and Grayscale. You'll want to able to read both of these spaces with the Eyedropper tool in Info, so you need to set up the palette to show them.

1. In the Info palette, click the arrow in the upper-right corner and choose Palette Options.

2. In First Color Readout, change Mode to Grayscale. In Second Color Readout, change Mode to RGB Color. In Mouse Coordinates, set the Ruler Units to Inches (or whatever you want). Click OK and put the Info palette in the palette well.

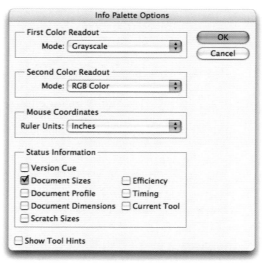

The Brushes Palette

One of the things I dislike about Photoshop is the proliferation of brushes that seem to come with every new revision of the software and abundant third-party offerings. The workflow for the Digital Fine Print Workshop requires only two brushes—one soft and one hard. By eliminating all the brushes except these two, you can save yourself much misery and headache. What do you do about size, you say? Use the right bracket key (]) on the keyboard to increase size and the left bracket key ([) to decrease size. No more cumbersome visits to the Options bar or right-clicking.

Here's how to set this up:

1. Open the Brushes palette and select a brush from the Photoshop CS2 Toolbox to activate the brushes in the palette.

2. Click the arrow in the upper-right corner and choose Small Thumbnail.

3. In the main brush window, place your cursor in the top left brush box (should be a Hard Round 1 pixel brush). Hold down the OPTION/ALT key and the cursor changes into a little pair of scissors (it's hidden under the hand in the #1 box in the following illustration). Click—and presto!—#1 disappears. Keep clicking in the same place until you get to Hard Round 19 pixels. Go to the next brush to the right of #19 and start clicking again until you get to Soft Round 21 pixels. Go to the brush to the right of #21 and click until all the other brushes are gone. Only #19 Hard and #21 Soft should remain.

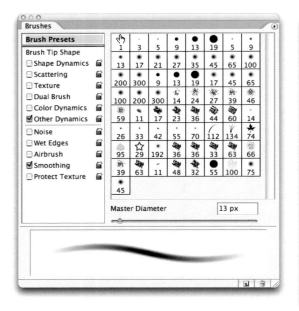

4. Click the arrow in the upper-right corner and choose Save Brushes. Type your name in the Save dialog box and click Save. You have now set up your two Photoshop brushes for all the work you'll do in digital printing. Dock the Brushes palette in the palette well.

The Actions Palette

Actions, to me, are an integral part of my work in Photoshop CS2. Without them, my time would at least be doubled in production, if not tripled. When I make an Action, I save it to the Photoshop Actions folder:

- **Mac** Choose Applications | Adobe Photoshop CS2 | Presets | Photoshop Actions

- **Windows** Choose Program Files | Adobe | Adobe Photoshop CS2 | Presets | Photoshop Actions

If you bring ready-made Actions into your computer, drag them into the Photoshop Actions folder as well. Then do the following:

1. Open the Actions palette, click the arrow in the upper-right corner, and choose Load Actions.

2. In the Load dialog box, navigate to the Photoshop Actions folder, select the Actions, and click Load (the Load Actions window defaults to the Photoshop Actions folder). The actions will appear in the Actions palette.

If you want to get rid of other Actions cluttering up the Actions palette (such as Default Actions), select them and drag them to the Trash Can icon at the bottom of the Actions palette. Dock the Actions palette in the palette well.

Saving the Workspace

Now that you've set up all these palettes, you want to save their configuration.

1. Choose Window | Workspace | Save Workspace. A Save Workspace dialog box appears.

2. Check the boxes for all three spaces: Palette Locations, Keyboard Shortcuts, and Menus.

3. Type your name, as shown in the example, and click Save.

If you want to reset your palettes to this workspace, choose Window | Workspace | *the name you typed in step 3*; then release the mouse button, and you'll go back to your custom workspace instantly.

Some Thoughts About Color Management

First of all, I am not an expert in color management, and second, this book is not about color management; but that doesn't mean I should ignore it. Color management is a complex and often exasperating subject. For those who work primarily in Photoshop without having to print photographs, color management is not as problematic, but color management for printing on an inkjet printer is the most confusing and greatest source of frustration to everyone involved in the photography business.

To help you sort it out, I recommend three books heartily and without hesitation:

- *Real World Color Management, Second Edition* by Bruce Fraser, Chris Murphy, and Fred Bunting (Peachpit Press, 2004)
- *Color Confidence: The Digital Photographer's Guide to Color Management* by Tim Grey (Sybex, 2004)
- *Color Management for Photographers: Hands on Techniques for Photoshop Users* by Andrew Rodney (Focal Press, 2005)

These books have helped me understand some, but not all, of the intricacies of this vast and important field.

What I have learned about color management for photography inkjet printing is this:

THE FIVE COMMANDMENTS OF DIGITAL FINE PRINTING

I THOU SHALT HAVE A CALIBRATED MONITOR.

II THOU SHALT HAVE HIGH QUALITY INPUT.

III THOU SHALT HAVE ACCURATE PRINTER PROFILES.

IV THOU SHALT HAVE ACCURATE COLOR SETTINGS IN PHOTOSHOP.

V THOU SHALT FOLLOW A CONSISTENT WORKFLOW.

I cast these learned lessons in religious phraseology and a typeface that denotes power (the typeface is Trajan, taken from the carved inscriptions on Roman stone columns and designed by Carol Twombly at Adobe Systems). They need to be printed, memorized, and spread throughout the world. They are lessons that required difficult travel to sacred places, and blood was shed.

I have discussed many of the aspects of the Five Commandments of Digital Fine Printing in appropriate chapters throughout the book. Here

I'll try to explain briefly why you need to pay attention to them in regard to color management. This is a discussion, without pictures, because you need to get your head around this stuff, not your eyes.

Every device used in the digital fine printing of photographs—camera, RAW converter, computer, monitor, Photoshop workspace, and printer (inks and paper)—requires a *profile*, a table of data that tells each specific device how to represent color. Camera and printer profiles are called *device-dependent* color spaces, because they can be used only for a particular camera or printer/ink/paper. *Device-independent* profiles, such as Adobe RGB (1998), sRGB, and ProPhoto RGB, are used as workspaces in the Photoshop Color Settings window. Many different color spaces, each with a different size, or *gamut,* tell us how many colors can be represented within that space. Getting all these devices and their respective color spaces to work with one another, with their individual gamuts, *is* the problem of color management.

Let's look at a working example.

I photograph with a Nikon D2X camera that lets me use one of two color spaces: sRGB (the default) or Adobe RGB (1998), a larger gamut color space. Certainly, I say to myself, I prefer a larger box of crayons over the smaller one, and more colors are available in the Adobe RGB "box" than in the sRGB one.

The next interface I have to go into is Adobe Camera Raw (if I'm shooting RAW files, which is most of the time), and here I have a choice, too: sRGB, Adobe RGB, ColorMatch RGB, and ProPhoto RGB. I guess that I want to use Adobe RGB to make the workflow simple and consistent—but then, haven't I forgotten the monitor calibration color space profile? With a laptop computer, that space is pathetically small, even when calibrated; on an expensive monitor such as the Apple Cinema Display, LaCie 321, or Eizo CG220, I get a much larger gamut profile and a view of the colors available to me. The Eizo CG220 is the only graphics monitor that allows me to view the whole Adobe RGB color space. It is also very expensive, more than the D2X. But let's suppose I have an Apple 23-inch display that shows much of the Adobe RGB space, but not all of it. Should I go back and change my camera profile to sRGB so that I can see every color, or do I "fudge" it in the Adobe RGB space? The conventional wisdom is to stay in Adobe RGB and fudge. Okay, so now I'm photographing in Adobe RGB, bringing the image into Camera Raw in Adobe RGB, and looking at it in a fudged, but not bad, monitor RGB.

Next comes the workspace in Photoshop CS2, and here I'm faced with more choices in the RGB Working Space popup in the Color Settings window. And, of course, I see my friend, Adobe RGB (1998), and rejoice at the (fairly) constant workflow I have. This is the crux of the problem: I have to convert the Photoshop workspace into a printer/ink/paper color space, which looks nothing like Adobe RGB. I not only have to use a different profile, but I have to choose what is called a *rendering intent* to "map" or change the Adobe RGB profile to the printer/ink/paper profile so that the printed image looks the same as the image on the monitor.

Four rendering intents are available, but only two, Perceptual and Relative Colorimetric, are of concern for inkjet printing photographs. *Perceptual* compresses one color space into the other, so that all the colors of the Adobe RGB space get squeezed into the printer/ink/paper profile space. The hues are maintained at the expense of saturation and brightness when this happens. *Relative Colorimetric* clips (removes) the out-of-gamut colors in the Adobe RGB space and replaces them with the closest colors in the printer/ink/paper space. So, which one do I use? The conventional wisdom is to use Relative Colorimetric, but no one has given me a good reason for this, until I discovered something recently. If I double-click an *ICC printer profile* (as they are called by the International Color Consortium), I can see the rendering intent with which it was made. To me, it makes sense to view images in Photoshop using a Perceptual rendering intent in Color Settings, and print with a rendering intent that is native to the printer profile—either Perceptual or Relative Colorimetric. But this is mentioned nowhere in all the color management literature I've seen. And the rendering intent varies with whoever made the profile. Most of Epson's profiles for the 2400 are Relative Colorimetric. Hahnemühle paper's profiles are Perceptual. All the profiles from ColorByte for the ImagePrint RIP are Perceptual. So if I'm going to print on an Epson paper, I need to be careful and use Relative Colorimetric in the Epson driver interface Print with Preview; when printing with ImagePrint, I must set ImagePrint's default Color Management Bitmap window settings to Perceptual. Once the image is printed, I have to view my picture under a light source that closely resembles the monitor color temperature calibration. It is perhaps possible that the color space used to create a profile is not necessarily the only one that can be used with it. You can see where all this gets really dicey. The

actual situation is somewhat more palatable. If you can't see the difference between Perceptual and Relative Colorimetric (look in the shadows), then there isn't much to be worried about.

I know of an equally compelling way to look at this problem. I can take my RAW file and consider that it doesn't matter which color space I photograph with (a RAW file is linear—it's just imaged data), because I can change it in Adobe Camera Raw. In this scenario, I can drop the image into the ProPhoto RGB space and put it into Photoshop (as an embedded profile) *as the working space* and then translate that into the printer workspace profile and print via the printer profile's native Rendering Intent. I can do this, say many proponents, because the ProPhoto RGB space is the largest color workspace available and it accommodates all of the other workspaces. I've found, though, that I have to alter the brightness of the image with Curves or Levels because it prints either too light or too dark.

Still another way uses the above scenario of the ProPhoto RGB RAW conversion workflow, except it substitutes the ProPhoto RGB color space for Adobe RGB (1998) as the default RGB workspace in Color Settings. When I do this, I have to alter the gamma of that space because it looks too light on the monitor, so I have to click and scroll until I get to Custom RGB in the RGB Working Space popup and change *only* the gamma window from 2.2 to as much as 2.6 to get the look I want.

This is the type of thinking color management requires and it is why it is so darned frustrating. Notice I didn't say that it was the "right" way. It's the *type* of process that may change with different printers, papers, and inks—and you have to pay attention to the details as well as the overall workflow involved. Remember the conductor and the orchestra?

My plan for the near future: Stick with the Adobe RGB (1998) workflow all the way from the camera to the printer interface and then change into the correct printer profile. Use a file with an embedded Adobe RGB profile and convert to the working space in Color Settings only if necessary. I am also going to be open to the new developments in ProPhoto RGB and adopt it when the debates for or against die down to a stable workflow solution.

Index